ABANDONED FARMHOUSES AND HOMESTEADS OF
NEBRASKA

DECAYING IN THE HEARTLAND

TRISH EKLUND

AMERICA
THROUGH TIME®
ADDING COLOR TO AMERICAN HISTORY

America Through Time is an imprint of Fonthill Media LLC
www.through-time.com
office@through-time.com

Published by Arcadia Publishing by arrangement with Fonthill Media LLC
For all general information, please contact Arcadia Publishing:
Telephone: 843-853-2070
Fax: 843-853-0044
E-mail: sales@arcadiapublishing.com
For customer service and orders:
Toll-Free 1-888-313-2665

www.arcadiapublishing.com

First published 2021

Copyright © Trish Eklund 2021

ISBN 978-1-63499-289-3

Typeset in Trade Gothic 10pt on 15pt
Printed and bound in England

CONTENTS

ABOUT THE AUTHOR

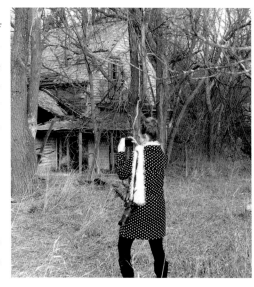

TRISH EKLUND'S first book, *Abandoned Nebraska: Echoes of Our Past*, was released in November of 2018. *Abandoned Farmhouses and Homesteads of Nebraska: Decaying in the Heartland* is her second book of photography. Trish's photography has been featured on Only in Nebraska, Raw Abandoned, ListVerse, Nature Takes Over, Grime Scene Investigators, and Pocket Abandoned. She is M.O.D. of @purebando_abarndoned. She is the owner and creator of the photography website, Abandoned, Forgotten, & Decayed. Trish has an essay in the anthology *Voices from the Plains Volume III* by Julie Haase, and the anthology *Hey, Who's In My House? Stepkids Speak Out* by Erin Mantz. Her writing has been featured on The Mighty, *Huffington Post Plus*, Making Midlife Matter, and Her View From Home. She has written four young adult novels and is working on her first adult novel.

INTRODUCTION

Home is where you feel safe enough to reveal your true self. Everything begins and ends in the home; it is where you raise your children and grow old with your spouse. Home is where you let your guard down. I think it is the biggest reason abandoned homes resonate with so many, especially farmhouses. The family farm is iconic. Seeing skeletal farmsteads scattered throughout the countryside is like seeing the death of small-town America. Farms represent the American family.

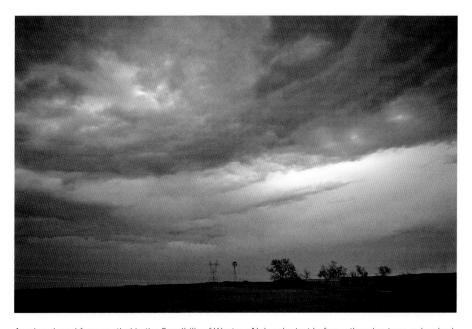

An abandoned farm nestled in the Sandhills of Western Nebraska just before a thunderstorm unleashed.

1

THE WARNER/BONWELL HOUSE

As I drove down the highway early one crisp morning, I noticed the corners of the roof of a little blue and white farmhouse peaking over the hill. I quickly pulled over and started taking a few photos from the base of the property, when I noticed a farmer on his ATV smiling and waving in my direction. My camera dangling from my neck, I reached in my pocket for a business card as I approached him.

"You from the County Assessor's office?" He shouted over the cars whooshing by.

I explained who I was and why I was interested in the old home. The farmer adjusted the brim of his cap, pointing toward the faded blue and white farmhouse nestled atop of the hill.

"You interested in the history of the home?"

I nodded, a smile pulling at my lips. "Absolutely!"

He fidgeted with his hat again. "If you hop on, I can even show you the house."

I rode up to the house with Ken, the farmer, and he began.

"Rose met Arnold and moved to the farm from Lincoln after they were married. There had originally been another home on the property when they were married, July 10, 1905, however, in 1913, a tornado swept through the area and completely leveled the original house, leaving the young couple next to nothing. Rose never much cared for the area and had been homesick since leaving her family home. Arnold went back to Lincoln, measured her parents' house inch by inch, and then built an exact replica for her on the hill, making sure she was comfortable in her new home." The porch swing groaned in the breeze. Even though Rose and Arnold have long passed, I felt their presence.

Ken showed me inside the home. Arnold had custom built all the wood, which was thick oak and still held the test of time. Lead crystal glass in the front door, built-in shelves with doors, and other little custom details made the house unique.

Ken slapped one of the kitchen countertops. "You'll notice all of the counter tops hit you kind of low?"

I nodded.

"Rose was only five-feet tall, so Arnold custom made everything to her height." He waved toward the bathroom.

Even the bathroom sink was lower. I wondered how tall Arnold was.

"Remarkable!" I walked around the home in awe of the craftmanship, imagining Rose and Arnold, and what they might have looked like.

"I have to run outside to speak to a guy really quick if you'll excuse me?" Ken stepped to the back door.

I asked if he would mind if I photographed the home while he was outside, and he gave permission. As I walked around, photographing as much of the interior as I could, I felt … strange. I couldn't put my finger on it. Without thinking, I spoke. "What a lovely home you have here, Rose," I said to the empty house. "Arnold built such a beautiful house!"

After I said those words, one of my cameras malfunctioned. The other one lost battery power instantly. Even though I still felt weird, I was never frightened or unnerved. I blew it off and continued.

I finished on the inside and went back outside; Ken had a bit more to share.

"When Rose became a widow, she only had $0.50 left in the bank, and the banker handed her the change from his pocket, and then told her there was no need for her to return. The end of her life was not the easiest. She had eggs to sell, and not much else." He paused, staring off at the house, like it was reminding him of what to say. "And are you at all familiar with the way the initial phones were setup — the party-lines?"

I nodded.

"Well, all of the older ladies would pick up, and eavesdrop on everyone else's phone calls." Laughter rose from deep within his belly. "And Rose was one of those ladies who loved to listen in. Boy, once they all started in, they would collect quite a bit of local gossip."

I told him it reminded me of Mrs. Olsen from *Little House on the Prairie*, listening in on people's calls, and we both chuckled.

"The house was on the fire department's burn list. I was ready to just get rid of it, ready to work the land and not worry about the upkeep anymore." He sighed and glanced back towards the house. "Even though I hated to see it go. One day I was leaving the store and someone stopped me. They asked if I would consider selling the house to be moved off of the land. I said, 'YES!' I had this sinking feeling I would come back and see a plume of smoke on the horizon, but luckily it was

still there. So, one day you will drive by and say, 'I remember when there used to be a house on that hill.'"

I waved goodbye to Ken, and later that day I went home to look at the photos I took. One of them especially surprised me.

After additional research, I discovered, Rosellen M. Merritt was born in 1885. She married Arnold Warner in July of 1905. He was her first husband.

Arnold Warner lived on the farm his entire life, with the exception of the two years he lived in Lincoln with Rose (I am assuming after the tornado, or right after they were married). He was born November 30, 1875, to Ebert and Sarah Warner. His father, Ebert, homesteaded the farm (the original house that was destroyed by the tornado in 1913 that Ken told me about). Ebert J. Warner was born in Onondaga County, New York, on June 4, 1852. He came to Nebraska with his mother and two sisters in 1863, and had been a resident since. He married Sarah A. Still on August 11, 1872. They had three children: two sons, Fred and Arnold, and a daughter, Sadie. His father passed away at age thirty-three, on January 22, 1886, of an illness. Upon his father's death, Arnold made a home for his mother and sister until their passing.

Sarah A. Still (Warner) was born in Bennington, Delaware County, Ohio, on October 13, 1849. She had stomach issues for months, which eventually resulted in her death on April 23, 1905. Her daughter, Sadie, died in 1906.

On December 29, 1933, as Arnold was driving on Highway 50, he hit mounds of dirt in the road. His car flipped. He suffered from memory lapses. Two weeks later he had a stroke. The doctor said there were complications from the car accident which killed him. I did not find anything stating he died in the home, but the articles alluded to it.

On July 13, 1905, Rose remarried a nice man, Lester Bonwell. Lester had children from a previous marriage, and it appears they were Rose's only children, as she and Lester never shared children of their own. Lester passed away after a long six-month illness in 1956. Rose passed away in 1978 at age ninety-three. The little blue house has been empty for many years, and is in remarkable shape for being vacant for so long. One would never know at a glance how many stories this one little house keeps within its walls. You would never know the wonderful things one young man did for his wife, mother, and sister.

When I look at the photos of the little blue house now, I picture Arnold and his parents. I see them watching over the house just as clearly as I picture Rose staring out of the window, waiting for her beloved.

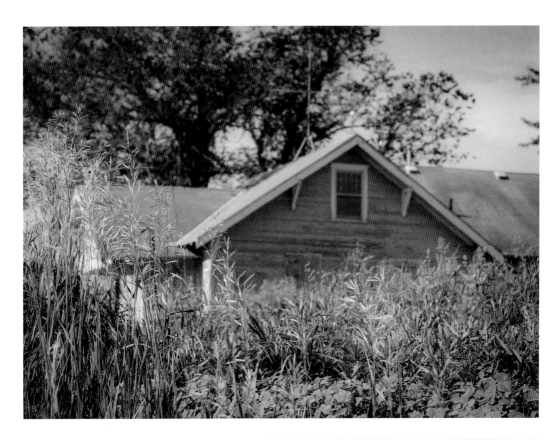

Above: The little blue and white farmhouse peeking over the hill in black and white.

Right: The house from the side view from the road.

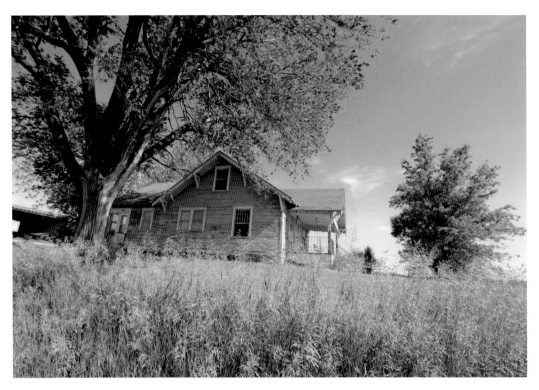

Side view of the little house.

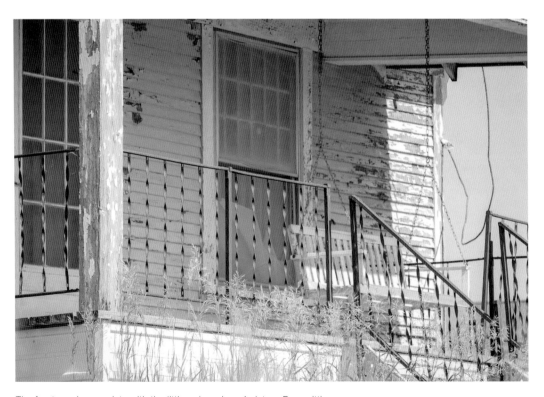

The front porch, complete with the little swing where I picture Rose sitting.

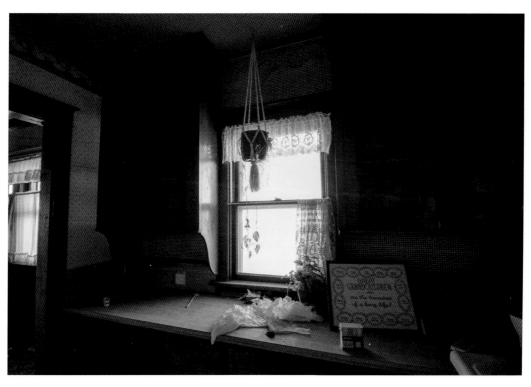

The kitchen, with countertops customized to Rose's height.

The front door and window.

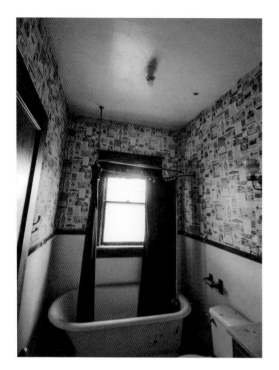 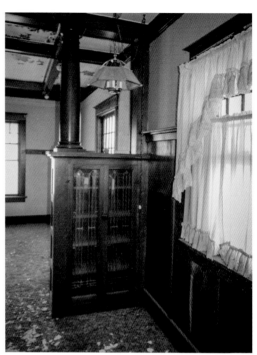

Above left: The bathroom. I really loved the newsprint wallpaper and the bathtub!

Above right: Built-ins with lead crystal.

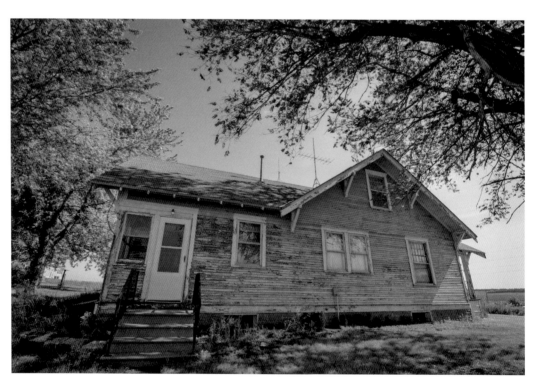

Side view of the house with the back door.

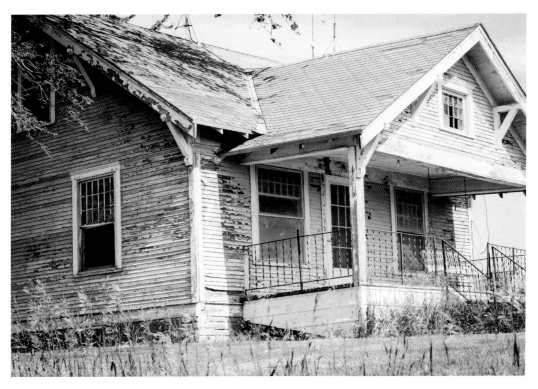

Black and white of the porch.

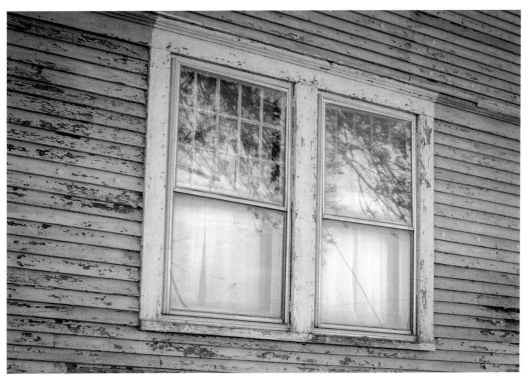

One of the windows where Rose once watched the sunrise.

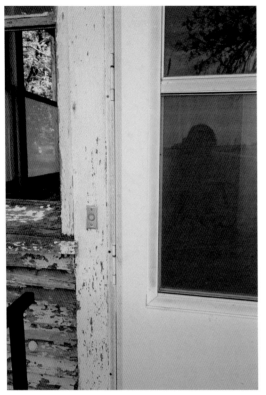

Taken from the exterior. There is a shadow or silhouette of a person in the screen door; however, if you look around the shadow, you can see the reflection of the land. There was no one inside the house. If it was my reflection, you would see features; also, I was not standing where you could see my reflection. The farmer was speaking to someone else on the property far away from the house at this time. Is that shadow Rose? To me, it resembles a woman hunched over with a bun. You can see wiry wisps of hair sticking out all around like it had come loose from the bun. I had straight hair that day and it was not in a bun. Also, it looks like a solid shadow to me.

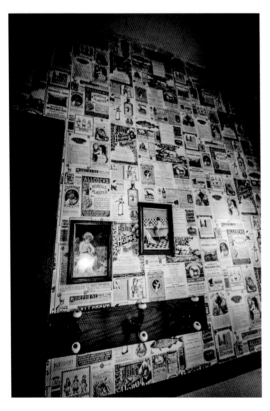

The black-and-white wallpaper in the bathroom.

Black and white of one of the windows from the interior.

Peeking around the corner into the kitchen.

The dining room in black and white.

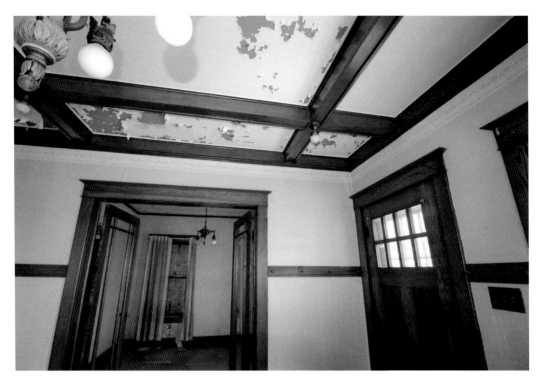

Living room, and doorway of dining room.

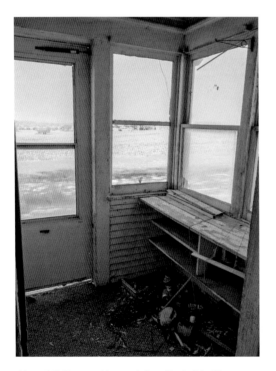

Above left: Screened-in porch from the inside. The same area I later saw the strange shadow in the screen door.

Above right: A close-up of the doorbell.

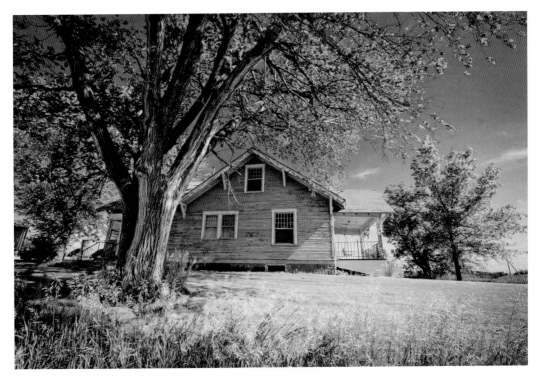

Black and white of Rose's home.

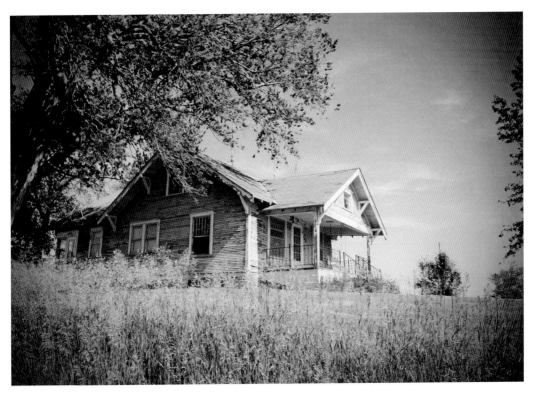

Black and white of Rose's home.

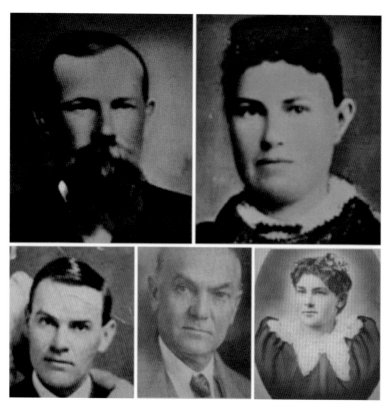

The Warners listed from the top: Ebert, Sarah; Bottom row: Arnold, his brother Fred, and his sister, Sadie. I was unable to find any photos of Rose.

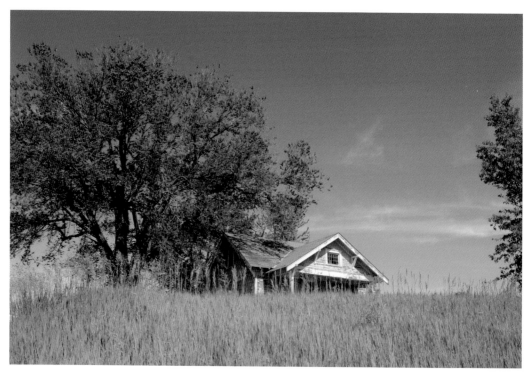

The house from down the hill.

2

THE KAHNK HOUSE

I briefly wrote about this farm in my first book, although at the time I was unable to find much history on the property. One of neighbors told me it had been rented out, and the final tenant left one day to never return. However, upon my most recent trip to the farm to uncover family history, I spoke to another neighbor, and I was pleasantly surprised. The farmer next door gave me the family's names and took one of my cards. According to the County Assessor's site, the house was built in 1876, but according to *History of Dodge and Washington Counties, Nebraska, and Their People, Volume 2*, the farm was homesteaded in 1869, 151 years ago.

John C. Kahnk, born December 14, 1824, in Germany, married Margaretha Junge Kahnk, and had their first child, Anna Kahnk (Cornelius). They moved to the United States in 1865; first to Illinois, where they had their second child, August Theodore Kahnk, on August 8, 1867. John first worked in a paper mill, until finally travelling by railroad to Washington County, Nebraska, in 1869. Rather than live on public land, he chose to buy school land at a dollar an acre. The first home was a small shack, and there were rumors that the family briefly lived on turnips. They had three other children, John, Dolf, and then Peter, who tragically drowned at age three.

Eventually, John acquired 120 acres, which he farmed. August was the only surviving son who grew up on the farm, while attending the local schools. He worked for his dad up to the age of twenty-three, and then he took over managing the farm thereafter.

August Kanhk married his first wife, Anna Mattheson, who passed away eight days after the birth of their son, Gustav A. Kahnk. They previously had two other children together, Meta and Margaret.

One month after his first wife's death, August remarried, to Lena C. Matthiesen Kahnk. Together, they had children Gustaf D., Anna C, Louis, Harry, Marie, Albert, Lillian, Arthur, and Clara.

Louie Kahnk, one of August's sons, was born July 17, 1905. He married Grace Suverkrubee on March 17, 1936, in Bennington, Nebraska. They continued to farm the land around the farm that John homesteaded.

In 1969, Louis and Grace won the Pioneer Award, for keeping the farm running and in the family for 100 years. Louis and Grace had one son, Lyle, who married Rita. Grace and Louie both lived to be in their eighties. Lyle and Rita also farmed the property, but had to move into town. They declined on speaking about the family or the property. I have found upon research of these properties that some of the families would prefer to keep their farms. Many of them are quite large, and require so much upkeep. If a family is lacking in help, or financial means, it is often easier to just let the property go. Louie was an only child, and the farm was too much to handle by himself.

When I look at the photographs of this 151-year-old property, I picture August, and the pride he must have felt when he first took ownership of this land. I spoke to the neighbor about the vandals who often show up on the farm. "There isn't much left to take, or to do to the place that hasn't been done," he told me, after I let him know I just wanted to photograph the place from the outside and through the windows

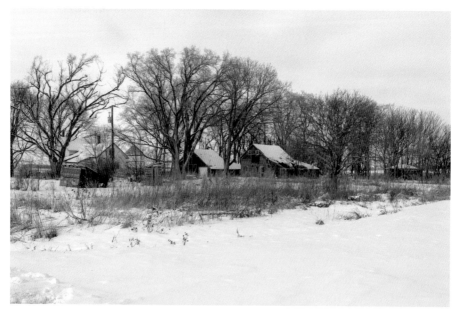

The Kahnk Farm in the middle of winter in 2015.

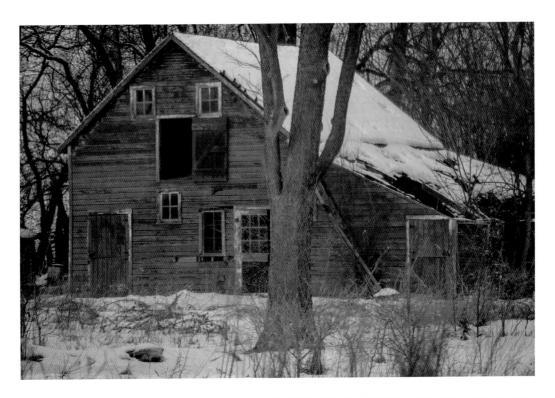

Above: One of two of the red barns on the property in the middle of winter.

Right: The outhouse, which was no longer standing the last time I went out to the property.

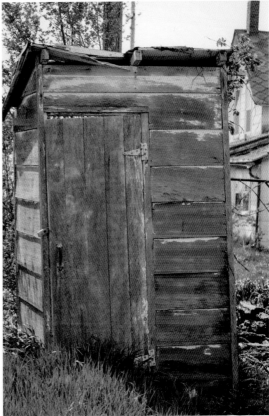

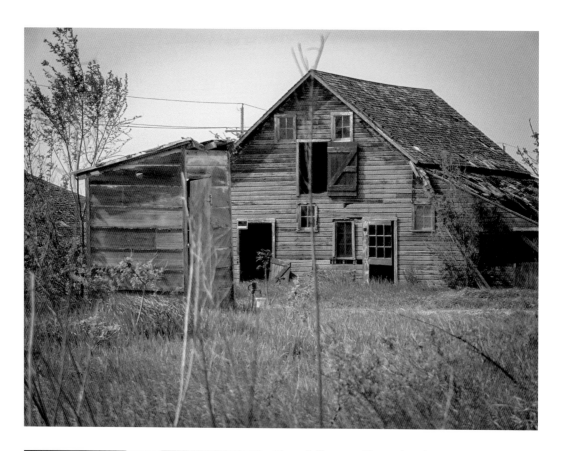

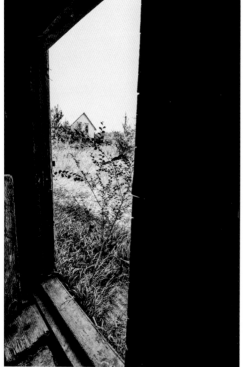

Above: Outhouse and barn, when the outhouse was still standing.

Left: Black-and-white view of the house from inside one of the barns.

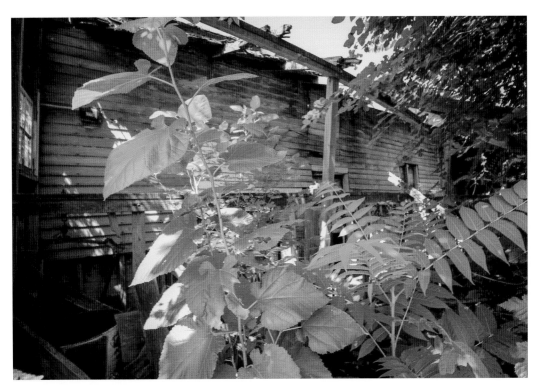

One of the barns, now overgrown.

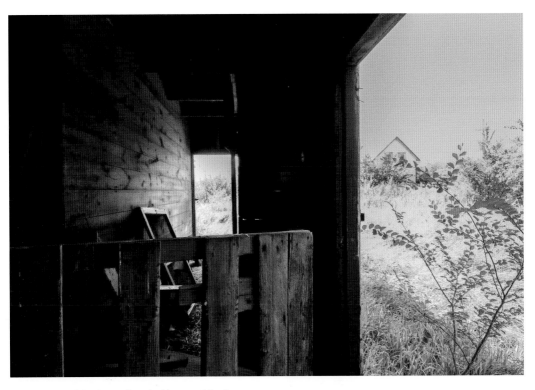

View of the house from inside one of the barns.

Above left: A plant growing out of a bucket of nails.

Above right: A chair in the front living room, seen from the open side window. The doily is still resting on the top of the chair, in spite of the surrounding decay.

Barn door falling off.

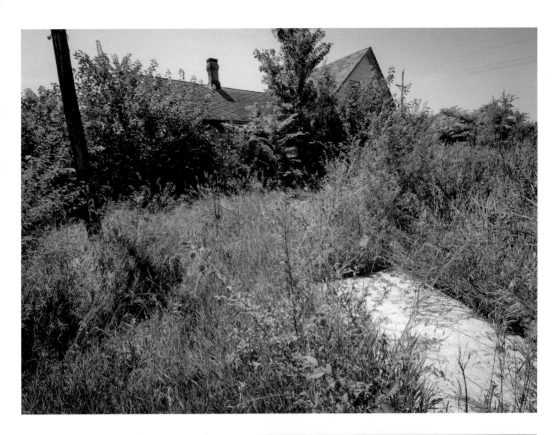

Above: The side of the house, and a mattress on the ground.

Right: Cobwebs from inside one of the barns.

Black and white of the house from the driveway with overgrown grass.

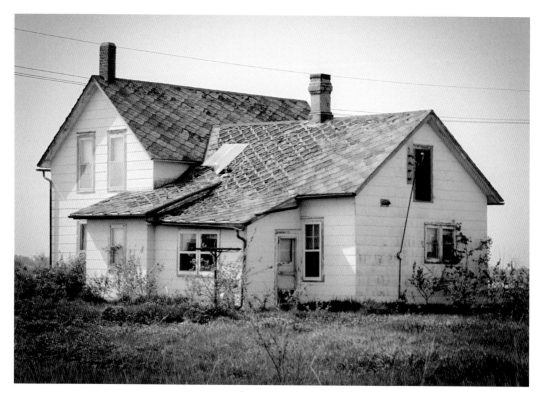

Black and white of the other side of the house before it became so overgrown.

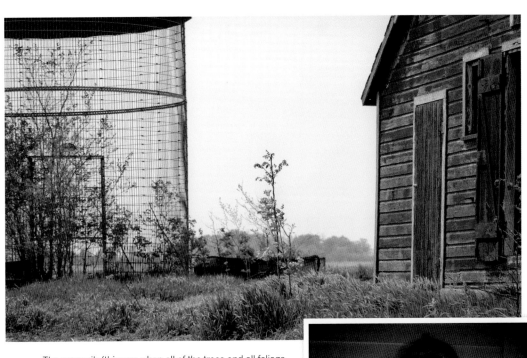

The corn crib (this was when all of the trees and all foliage had been trimmed, so you could see everything better), and a portion of one of the barns. *Right:* A gardening hat hanging on the wall, visible from the glass screen door (this was before the house had been broken into). The last time I visited it was gone, and the house was open and vandalized.

A black and white of the cream sherry bottle in one of the outbuildings. It was gone the last time I returned.

3

THE BURGER FARM (CLARA'S FARM)

The next farm is very close to my heart. My late father-in-law, Denny (my ex-husband's father), loved my photography, and he planned to take me to see the farm where his mother grew up. Unfortunately, he lost his long battle to cancer, so I never had the opportunity to make the day trip with him. My ex-husband was nice enough to give me directions to the farm. One of his uncles, and one of his cousins, Neal (who now owns the property), met me out on the farm.

The trees and grass have nearly swallowed the house, and if you were unaware of the property, you would drive right by.

It was estimated from the family that the first house was built between 1858-1860. The second house, the current house, was built between 1912-1920. The original farmhouse was still standing in 1949. "Grandma moved to town in 1974, and the house was rented out for several years after that," Neal recalled.

The original house was torn down. The last time I went down there, I looked for the foundation and I couldn't find it. After walking into the fifth cobweb with my face, complete with enormous spider attached, I gave up!

Ernest Herman Burger was born in Georgia in 1892, to Mary C. Burger (Coggins) and Charles H. Burger. Ernest married Augusta Katherine Huss (born in 1895) on March 29, 1922. Augusta's family was from Germany. Together, they had five children: Harry, Albert, Rosie, Clara (Denny's mother), and Helen (Neal's mother).

Krissy and Vicki both remember their grandparents house as being haunted from when they were little. Neal once asked Albert if he knew any reason it would be haunted, such as if someone possibly died on the property, but nothing came to mind.

Neal still farms the land around the house, and he wishes he could have done more to save the farmhouse, but it was just too far gone. Neighbors who live in the area, and Neal himself, are always on the lookout for trespassers and vandals.

The house is in pretty rough shape, especially the upstairs where the floors have rotted completely through and are caving in. Someone could fall through if they are unsure where to step.

The house did not have an indoor bathroom for years—they used an outhouse. Roger and Neal recalled stories about their parents bathing in an old washtub on the back porch. At one point, before the back porch was enclosed, the kids were bathed in the open. Roma people who passed through the area often spoke to the kids or asked for food, so this led to an enclosed porch where the kids could bathe privately.

This family is what you picture when you think of an American farm. The Burgers raised their children with home-cooked meals, church on Sundays, daily chores, respecting their elders, and loving their community. Denny is one of the best people I have ever known in my life, and I am so very blessed to have had him in my life.

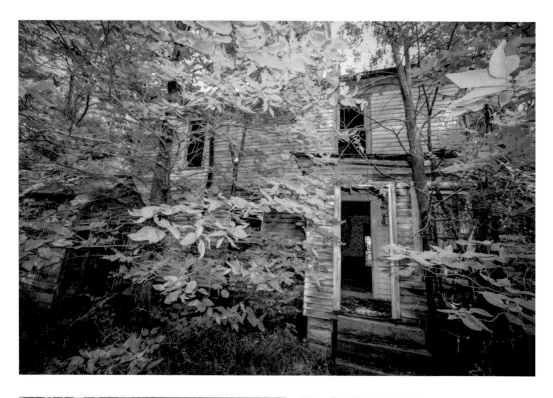

Above: The front side of the house.

Left: From inside the chicken coup.

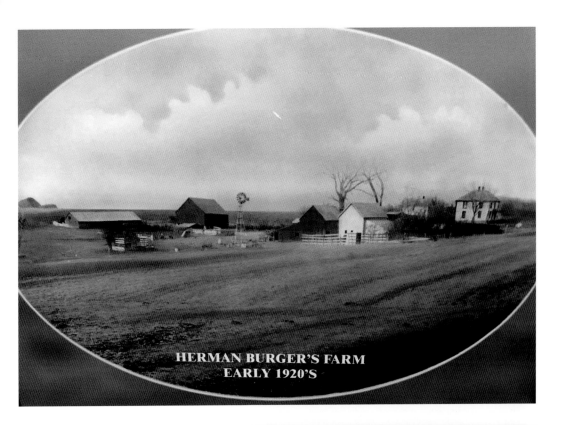

**HERMAN BURGER'S FARM
EARLY 1920'S**

Above: The Herman Burger Farm in the early 1920s, when the first house was still on the property (directly behind the new house in the trees). The original house was torn down.

Right: View from inside what once was the kitchen, looking outside.

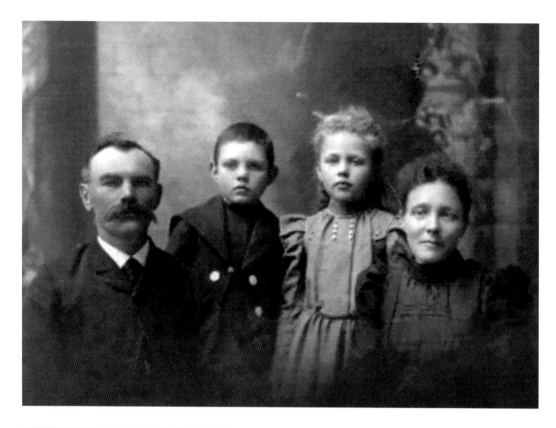

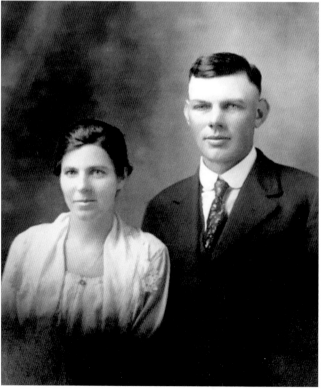

Above: Herman with his wife (Butt), and their children, Ernest (Denny's grandpa), and Anna. Herman came to America from Germany.

Left: Ernest and Augusta Burger (Clara's parents, and Denny's grandparents).

One of the outbuildings.

Side view of the house in black and white.

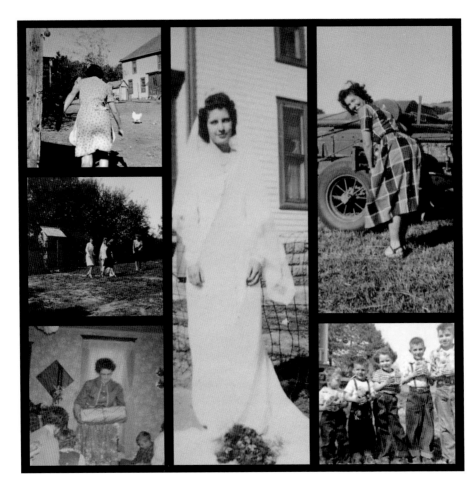

Above: Starting from the top left: Clara feeding the chickens; Middle: Clara on her wedding day; Top far right: Clara leaning over the plow. Far left middle row: The outhouse on Clara's wedding day; Bottom left: Mrs. Burger, and the kids at Christmas; The far right: Gail, Roger, Bev (Gail's sister), Gary, and Denny (my late father-in-law).

Left: Beautiful peeling wallpaper on one of the walls upstairs.

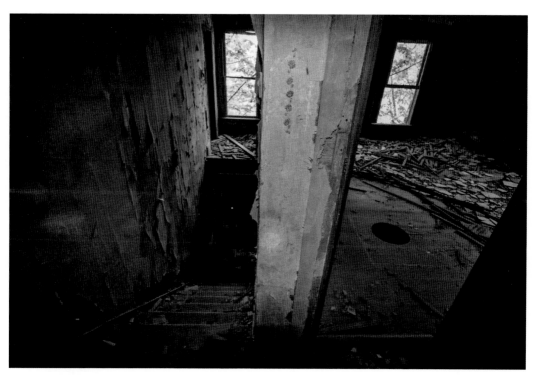

Upstairs looking down, with the little rose details of the wallpaper in between. This is one of my favorite photos of the home.

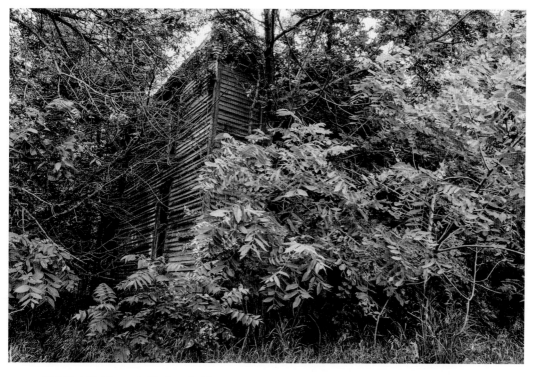

Outside of the house in black and white.

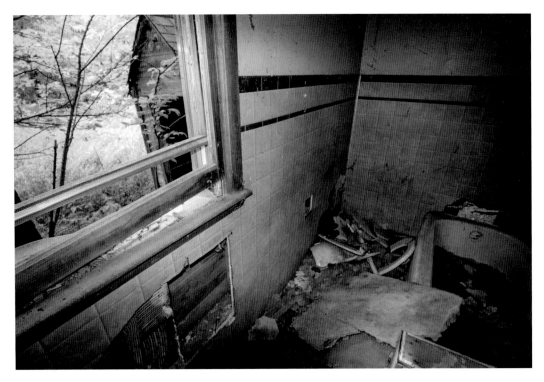

The one bathroom in the house.

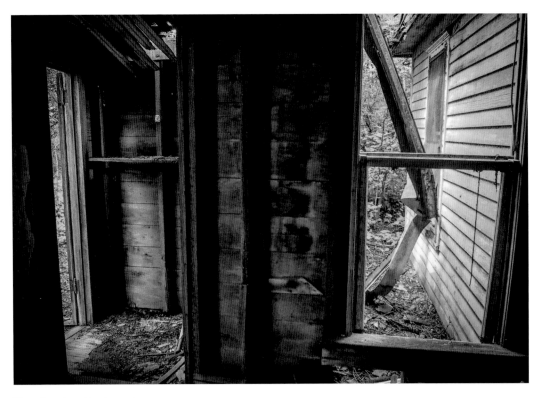

View of enclosed back porch.

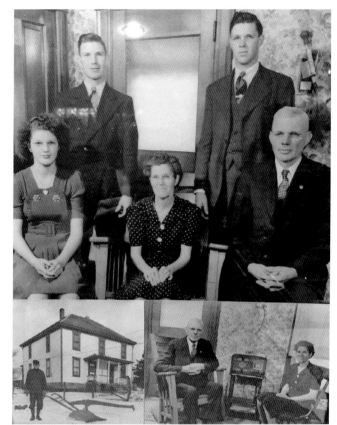

Right: Sears came to the house to interview the family because they purchased so many items from them; the radio, and chairs they sat in, and the plow. Top: Albert, Harry, Rosie, Grandma, and Grandpa. Bottom left: Mr. Burger in front of the house with his plow he purchased from Sears. Bottom right: Grandma and Grandpa Burger with their radio from Sears.

Below: The front of the house.

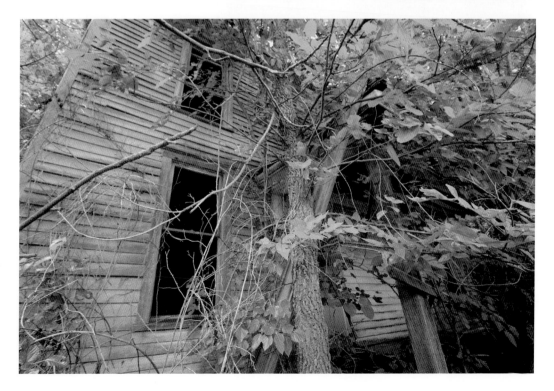

Wallpaper in one of the bedrooms.

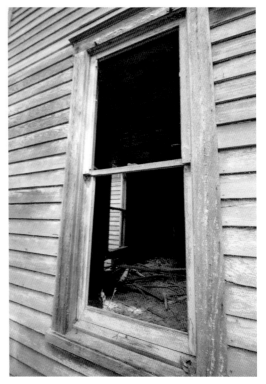

Looking into one of the back windows.

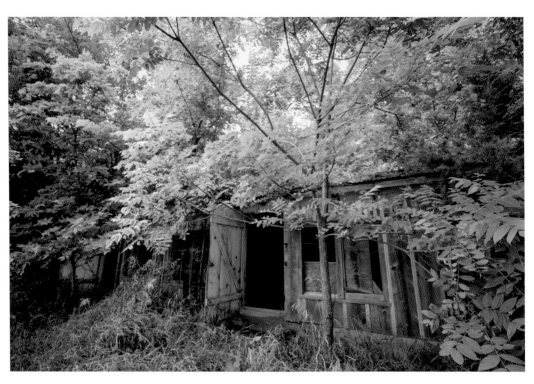

The chicken coup.

Above: Exposed fireplace from upstairs.

Right: The house has lost its white paint, and the wood is splintered, but it still holds so many memories.

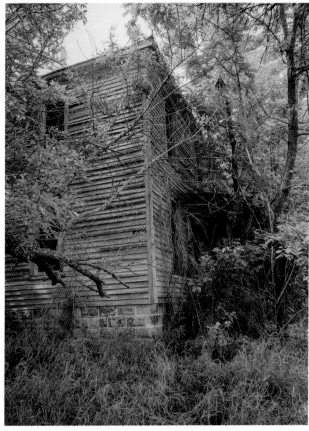

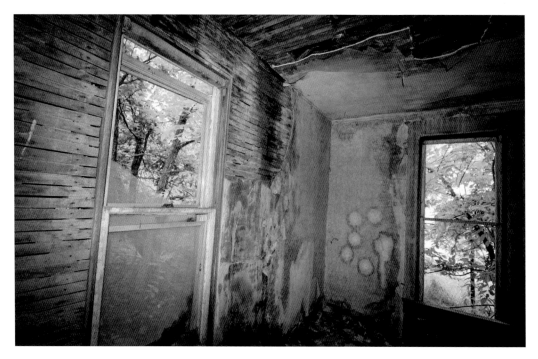

Contrast between the windows and the decay of the walls.

An old paint can left behind in the chicken coup, encased in cobwebs.

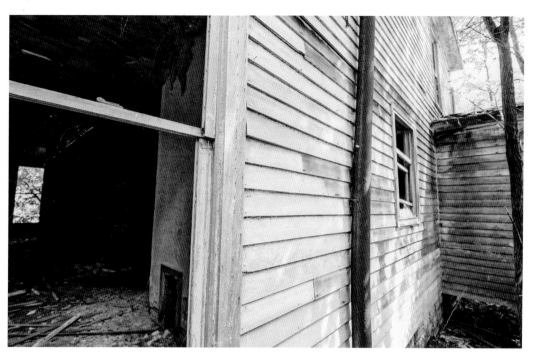

The back of the house looking inside one of the windows, in black and white.

Broken glass in front of the chicken coup wire.

4

THE MARK STERLING MORTON HOUSE

The next two houses were in my first book. They are two of my old favorites; however, I never knew much about either of them. In researching them, I was pleasantly surprised what I found out.

If you live in Nebraska, you have most likely heard about J. Sterling Morton, or Julius Sterling Morton – the founder of Arbor Day.

Julius Sterling Morton was born in New York in 1832. He obtained his bachelor's degree from the University of Michigan. He married his high school girlfriend, Caroline (Carrie) Joy French, and they settled in the Nebraska area in 1855, purchasing 160 acres around Nebraska City.

J Sterling Morton was editor of the newspaper *Nebraska City News*, and he served as United States Secretary of Agriculture for President Grover Cleveland. Twice, he served as acting governor, but was never allowed to take his seat in the United States House of Representatives as his election was contested in the Republican House.

He was the founder of Arbor Day, which is now recognized as a National Holiday. Arbor Day is celebrated the last Friday in April. Together, he and Carrie had four sons: the eldest was Joy, who founded Morton Salt Company with his brother Mark. There was also Paul, and Carl, the youngest.

Caroline died June 29, 1881 at only forty-seven years old, from a knee injury that never quite healed. Her husband was devastated.

This house belonged to his son, Mark Sterling Morton. The current owner said it was Mark's summer home.

Mark Morton was born November 22, 1858. He grew up in the family home, Arbor Lodge, and attended the public schools in Nebraska City. At age eighteen, he began working with his older brother, Paul as a clerk for the Burlington Railroad. In 1882, he was a salesman for Harvey Lumber Company of Chicago, and in 1890, he was

the superintendent of the main plant of the Nebraska Packing Company. Later, he was also president of the Western Cold Storage Company (major builder and provider of refrigerator storage facilities and railroad cars for the meatpacking industry).

Mark and his older brother, Joy, co-founded Joy Morton Lumber Company in 1885. They later co-founded the Morton Sand and Gravel Company. Together, they purchased Richmond and Company, a salt distributor in 1886, and named it Joy Morton and Company. Mark was the VP, one of the directors, and founder until his retirement in 1922. Next, it became the International Salt Company in 1902, and incorporated as Morton Salt Company in 1910.

Mark married Martha Parkhurst in 1887, and together they had four children: Joy Morton II, Jane Morton, Helen Morton, and Laura Weare Morton, who passed away at the tender age of four from Scarlet Fever over Thanksgiving.

In 1914, Mark's daughter, Helen, eloped with Col. Roger Bayly. Morton found his daughter, and challenged her marriage on the grounds of mental instability. The court ruled in his favor. Helen was committed to an asylum. The allegation was a national scandal which embarrassed Mr. Morton. When distinguished journalist, Webb Miller, attempted to interview her, Mark hit him over the head, tied him up with the help of his hired hand, and put him in his trunk. They crashed head-on, and police found Mr. Miller in the car. The journalist sued and won a small sum, six years later, a fraction of what he originally sought.

In 1931 after retirement, Mark built a mansion and settled in what is now Carol Stream (DuPage County), Illinois. He raised and bred horses, cattle, sheep, and many other animals. He was one of the International Livestock Exhibitions. He was seriously injured in 1937 when a train struck his car at a crossing.

Mark died at his home after a lengthy illness on June 25, 1951, at the age of ninety-two. He left the bulk of his 750,000-dollar fortune to charity. His daughter, Helen, died in 1954 after living in Phoenix for seven years, at age sixty-one, after a yearlong struggle with metastatic bladder cancer. She had one child, William Swift.

In order to find out more about this house, I stopped by the neighbor's house. They informed me of the current owner's name, and where I could find them. She also told me the house had quite a past, including that Mark Morton once owned the home. She shared a rumor she heard that someone was hung in the house. She was not sure if the person hung themselves or if they were hung by someone else. I am unsure of the validity of this information, as I never found any evidence to support it. The home had the title of Parkhurst Farm, after his wife's maiden name.

I found my way to the current owners' home, where a gentleman in his seventies or eighties worked in his yard. He rested on the shovel, squinting toward me and my car, waiting for me to reveal my identity.

"Hi, are you Mr. Lutz?" I opened my car door and approached him so he could better hear me.

His eyes probed. "I could be, depending on what you want!"

I giggled, explaining who I was and what I wanted. He agreed to speak to me. "I'm gonna have to sit down for this."

I grabbed my notebook and pen from the car to join him. I joined Mr. Lutz on his porch, sitting next to him on the bench.

"I was fourteen years old when my parents took me with them to an auction. My mother didn't even get out of the car. My dad bid on the house on the front porch, and I was right next to him. We never even saw the inside of the house. That was back in the '50s. Years later the house was my mother's. Once she died, we had our current house built, and we couldn't keep up with it." He paused, staring off toward the highway. "We had several rental tenants, and every one of them pulled something. One burned the barn down. We thought were doing okay with the last tenants, until we got a phone call one night." He recounted the situation with his last tenants. They had been arrested.

Then his wife came outside. "I thought I heard you talking to someone out here."

I explained to her who I was. She shared that her husband had suffered from a stroke. I could tell she checked on him often to make sure he was okay. "He sometimes tries to say one thing and another comes out. His mother didn't want to let go of that house. We just couldn't maintain it. We had tenants renting it until we couldn't do it anymore." He nodded. "We just couldn't do it anymore. One tenant even had a large dog chained up in the basement that they left down there. It had scratched up the wall trying to get free, and had gone to the bathroom all over the floor." She began talking about the last renters, and he joined in. When they arrived at the house, the entire thing was full of stolen merchandise. "There were bicycle wheels, new bicycles, and other stolen stuff pilled all over the house. There was a deep freeze in the house, with no electricity, full of stolen meat, so ALL of it had gone rotten. The smell was awful." Mrs. Lutz had to wear shoulder-length gloves to get it out. Mr. Lutz held a big trash open, and she reached into the freezer and tossed the rotting meat into the bag.

They shared with me The Mortons would sit on that big porch watching horse races. As far as the hanging, the Lutzes didn't know if the rumor was true.

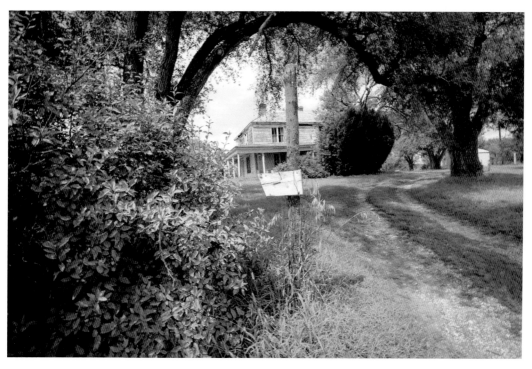

Mark Sterling Morton's house as you are driving up. Such a picturesque place.

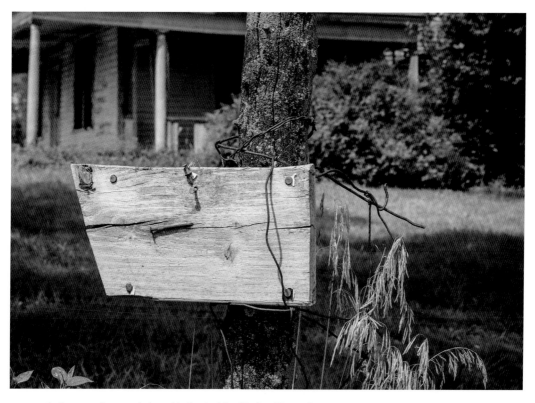

A close-up of an empty board in front of the Sterling Morton home.

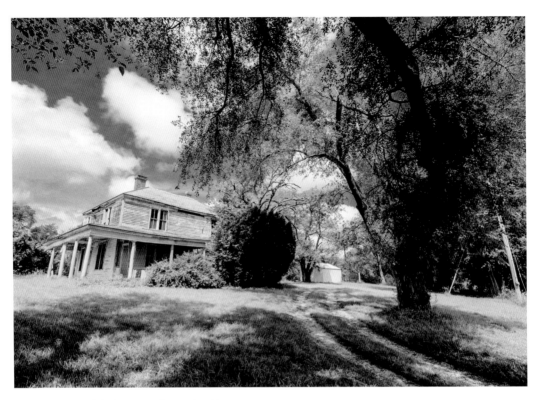

Black and white of the house coming up the drive.

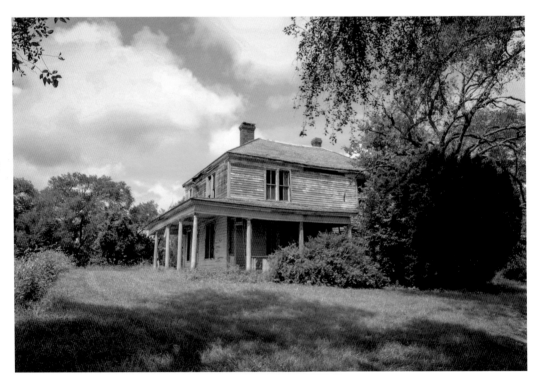

This home has such beautiful bones.

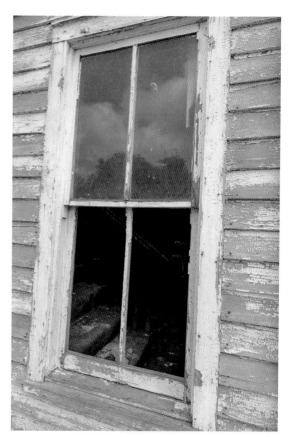

Right: One of the side windows, exposing the main staircase. According to the current owner there is a back staircase that was once used by "the help."

Below: Black and white of the front, and what once was a screened-in porch on the side.

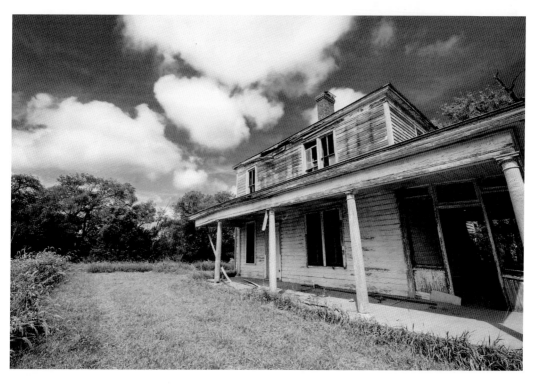

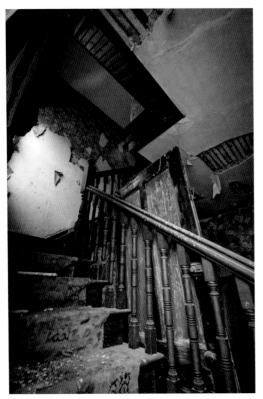

Left: The staircase, from peering in from the open window.

Below: A black and white of the porch from the side.

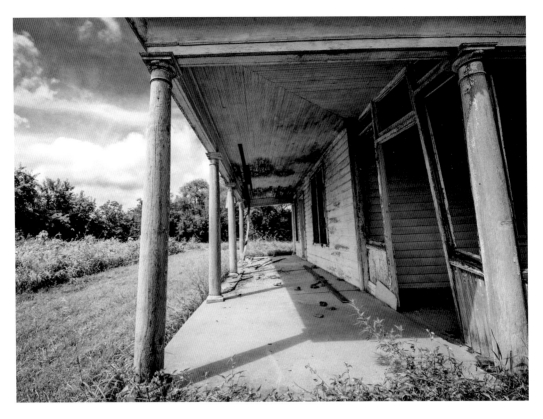

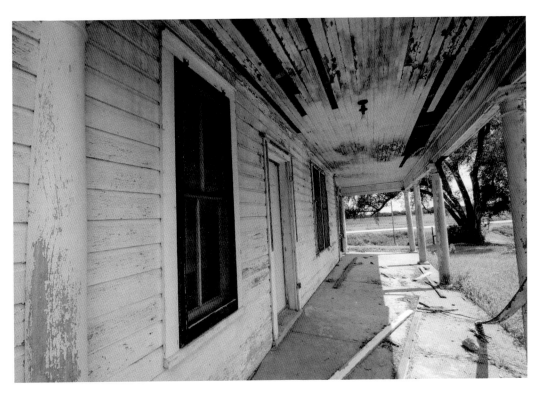

A color photo of the porch.

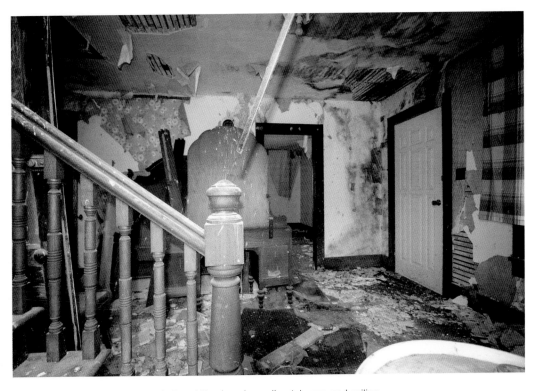

Peering inside the open window at the decaying walls, staircase, and ceiling.

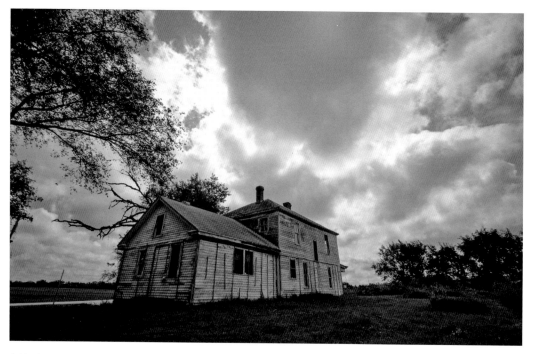

A black and white of the back of the home.

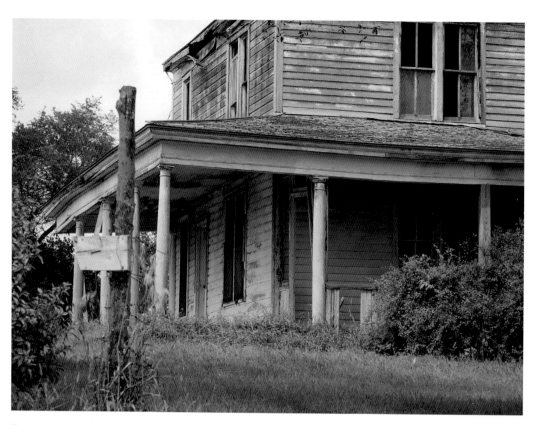

The porch of this house is my favorite of all the homes I have explored.

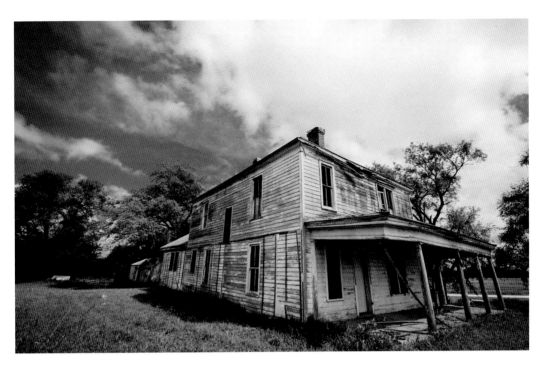

A black and white of the house.

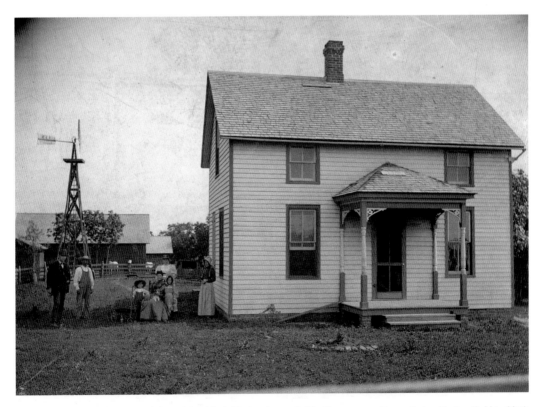

Parkhurst Farm: from left to right: Mark Morton (owner), Mr. Bruggeman (farmer), Joy Morton II, Mrs. Mark Morton, Jane and Helen standing, Mrs. Bruggeman.

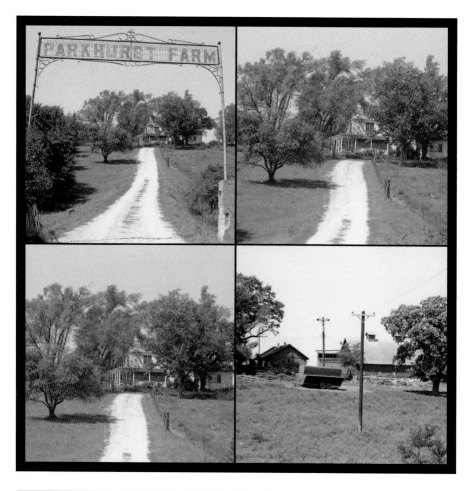

Above: Parkhurst Farm in the 1970s. The photos were provided from History Nebraska.

Left: Inside the house from an open window.

5

THE LUTZ'S OLD HOUSE DOWN THE ROAD

The next house is actually just down the highway from Mark Sterling Morton's old summer house. The Lutzes also shared they lived in this home for eighteen years!

This particular house has paranormal activity associated with it. Every time I have visited, it has drained all my electronics, and it usually makes me feel ill. I have also heard noises on more than one occasion, besides the usual creaking abandoned house and wild animal noises.

This one was built in 1900, per the county assessor's website. The Lutzes no longer own this house; another farmer currently owns this property and farms the land. The building is unstable, so I photographed around the outside, and just inside the front door.

Looking up the stairs, I imagine the Lutz children trotting down when they smelled cookies baking in the kitchen. When I looked into the kitchen at jagged shards of glass, cabinet doors barely hanging on, and peeling walls, I still see what a large, magnificent kitchen it once was.

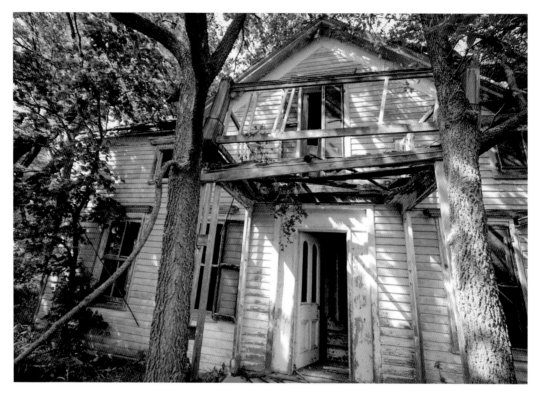

The house on the hill that the Lutzes lived in for eighteen years.

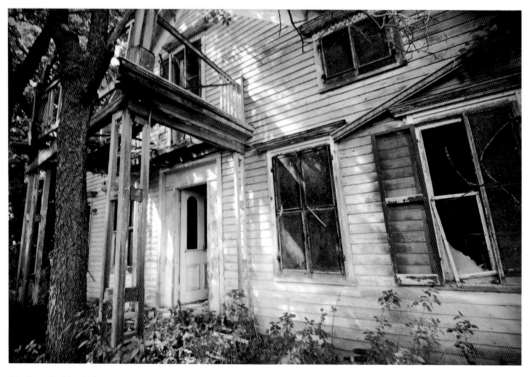

Black-and-white fade.

One of the front windows looking inside.

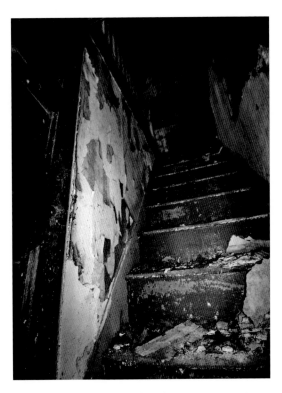

The staircase just inside the front door.

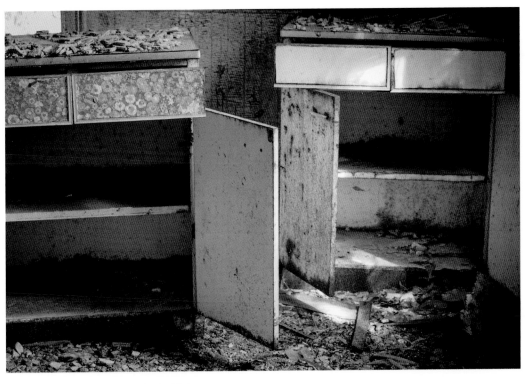

What is left of cabinets in the kitchen.

The other side of the house from a distance. I love this angle. *Left:* A black-and-white photo of the back of the house.

Looking up at the upstairs balcony, which has completely fallen in, and the balcony doors to what I assume was the master bedroom.

6

NANCE COUNTY

N ance County has really interesting abandoned places. I was lucky to have a personal tour guide who farms in the area. Nance County once belonged to the Pawnee nation, who flourished along the Loup River by hunting game and planting crops. It was eventually selected as the Pawnee Reservation. In 1855, A group of Mormons led by Henry James Hudson were the first white settlers to venture to the area. Today, the initial colony site is called Genoa, where 100 families first came to Nebraska. Even though it thrived, the territory was claimed by the Pawnees in 1860 to be part of their reservation. Eventually, the danger from the struggles between the Sioux and Pawnee tribes urged the Mormons to leave the area in 1864. Randall Fuller ventured to the area twelve years later, on his way to the Black Hills with his herd of cattle. He bought two sections of the reservation land that was being parcelled off. Today the town site of Fullerton is the county seat. The county was defined in 1879, named after the governor, Albinus Nance.

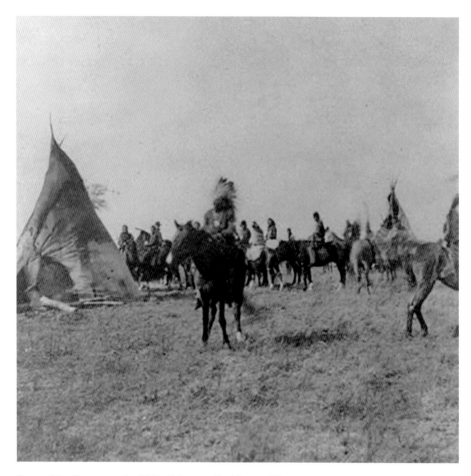

Camp of the Pawnee on the Platte Valley, per the Library of Congress.

THE HORSE CREEK MURDERS

In 1884, there was a little settlement of well-to-do Englishmen out in Nance County, twelve miles west of Fullerton. The group had only recently arrived in Nebraska to try their hand at farming. The land is also the site of a former Pawnee village, abandoned since 1842. Henry Perceval, who was a wealthy landowner and cattle rancher, met his wife, Mary Cornelia Tanner, on the way to Nebraska. Mary was the daughter of the rector of Owatonna, Minnesota — George Tanner. Together, they had a daughter, Ellen Mary Percival. Ellen was eleven-months-old, and Mary was pregnant with their second baby when she was killed. Their home was named "Arden Farm," after one of the Perceval family titles. Harry Baird, who was the Perceval's live-in hired hand, and long-time friend of Henry's aunt, was married to a cousin of Harry's. The other victim was Hugh Mair, the neighbor, who was from a family of well-off merchants.

Hugh was a business partner, and close friend of Henry's. He shared a home with George Furnivall. George's father was a farmer in Surrey, and his grandfather was a surgeon. Frederick James Furnivall, a well-known barrister, was his uncle.

Authorities believe the murders took place on September 29, 1884. The next morning, the bodies of Henry Godfrey Percival, his young daughter, Ellen, pregnant wife, Mary, hired hand, Harry, and neighbor, Hugh Mair, were all found dead. According to one story, Mary and Ellen were found in the bed. They had both been shot in the head. Another article stated Mary obstructed the door, which was smashed with an axe. Henry's body was found close to the barn covered in straw, with his horses still harnessed to the wagon. The horses had not been fed in days. Henry had been shot in the body and head, with one arm broken, which caused authorities to suspect he fought with his murderer. He was half devoured by his hogs. Hugh Mair (the neighbor and George Furnival's roommate) was found in his bed, shot in the head, with a ripped pillowcase covering his head and shoulders.

George Furnival (Hugh Mair's roommate) and Harry Baird (Henry's live-in hired hand) were both missing. Many thought Baird was responsible, until his body was found in Horse Creek, buzzards circling over his body. Some theories about the murders are that there was an argument over a woman, and Furnivall was jealous of Mair and shot him in bed. He allegedly killed the others to cover it up. Another theory is Percival was to inherit money, and someone in England paid Furnivall to kill him so he would receive the money instead. Multiple witnesses claimed they saw Furnivall wearing Baird and Mair's clothing at the closest railroad depot. Furnivall was spotted in Mississippi, California, and Canada. The Fullerton authorities received a letter in 1933, inquiring about George Furnivall, asking if he was still wanted in connection with the murders. The writer of the letter was someone in Redwood City, California. There was a Frederick John Vincent Furnivall, who was a cousin of George, traced to the area. There was a theory that Furnivall himself went to authorities to relieve his conscience, most likely elderly and possibly unwell by that time. The letter was turned in to the Nance county attorney, but never pursued.

Some of the articles I read contained letters from people who stayed in the house as tenants after the murders. Tenants never stayed long, as there were claims of strange noises like moaning, hammering, and sawing, and one woman complained about a rocking chair rocking by itself. There was also a blood stain that would never come clean even when it was scraped up. The house the Percivals lived in was torn down, and another house was built from the wood, according to the farmer who gave me my tour. It was moved away from the land, but the people who lived in the house still experienced paranormal activity. I read the house eventually burned down.

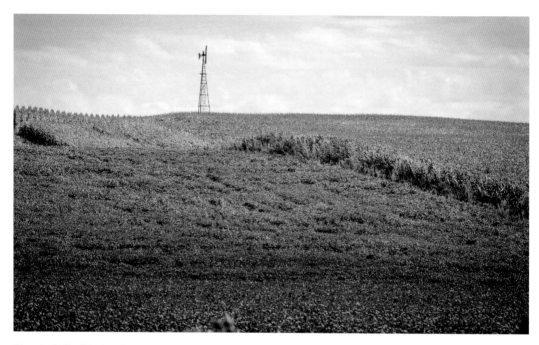

The windmill off in the distance is the only thing left of the homestead where the lifeless bodies of a young pregnant mother and her young daughter were found. Gazing at the green rolling hills and blue skies, you would never imagine the horrors that once occurred there.

Close to where Harry's body was found so many years ago.

G. P. AND IDA'S HOUSE

The next house belonged to a couple, Ida and George Phillip (G. P.) Luft. They were married April 26, 1905. Ida T (Holtz) Luft was born November 6, 1885, and lived until October 1980, at the age of ninety-four. G. P. was born December 3, 1875 to August 28, 1977, age 101.

They had several children: Josephine, Raymond, William (nick named Wild Bill), Vernon, and Vera. In 1926, they moved to the farm via wagon.

When times were difficult, during the 1920s and 1930s, they had several stills on the farm under the hog pens making corn whiskey. They fed the mash to the hogs to hide the process from the revenuers. If not for the stills, they would have lost the farm and everything else. I did not find out about the stills until after I left the farm; otherwise, I would have searched for them.

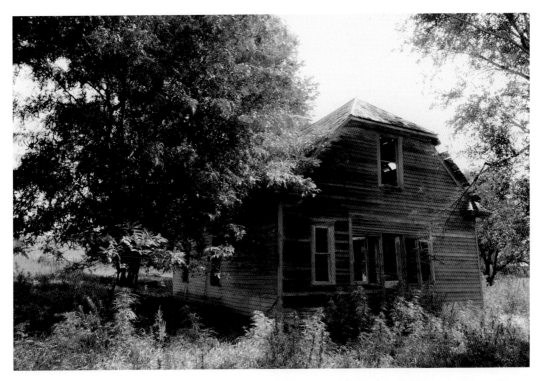

A black and white of G. P. and Ida's house. I love the shape of the roofline of this house. It reminds me of a barn.

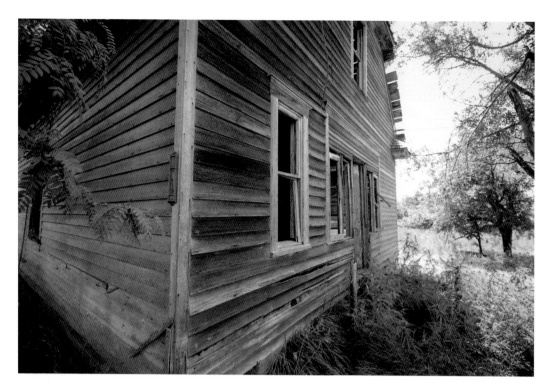

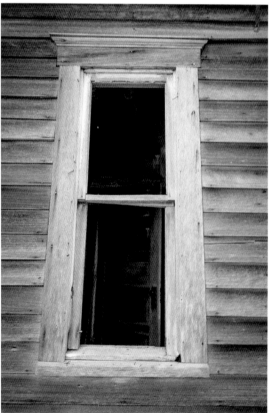

Above: The side view of the house.

Left: A shot of a door through the window.

The horse trough.

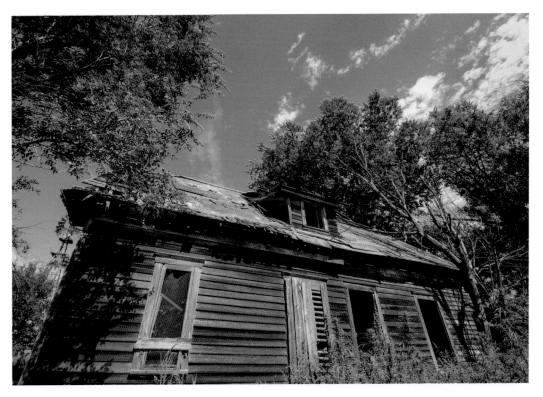

The back of the house.

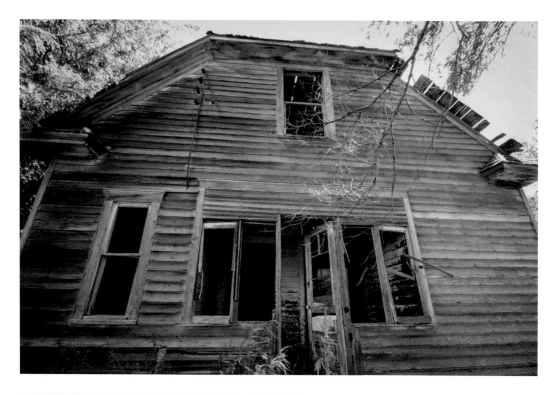

Above: Here is that fantastic roofline again.

Left: A close-up of the bottom of an old rotting chair, and kitchen appliances.

THE HONEYMOON FARM

The next house belonged to Edna McCoig, who married Arthur Webb. They lived in the home for a year during their honeymoon. I really loved this little farm. I picture a newly married couple waking up with the warmth of the sun in the morning.

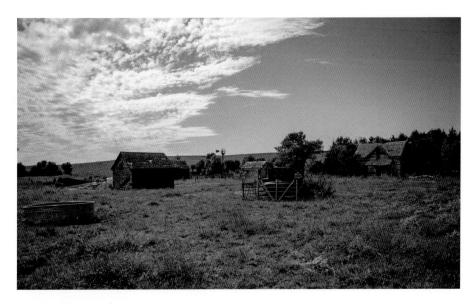

A photo of the entire farm.

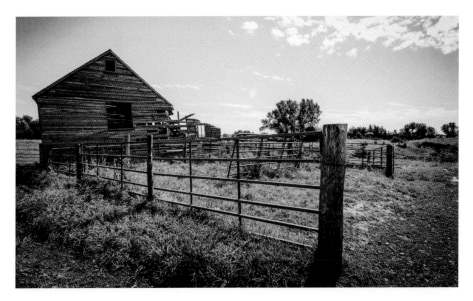

One of the barns in black and white.

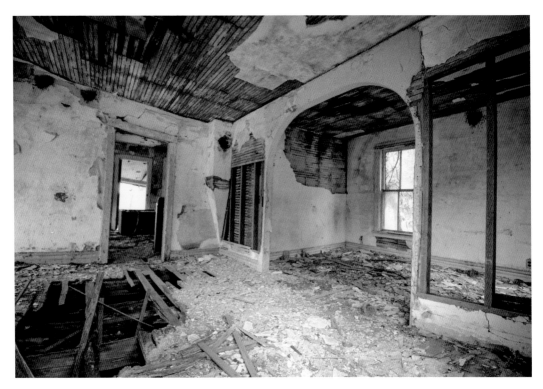

Looking inside from the window.

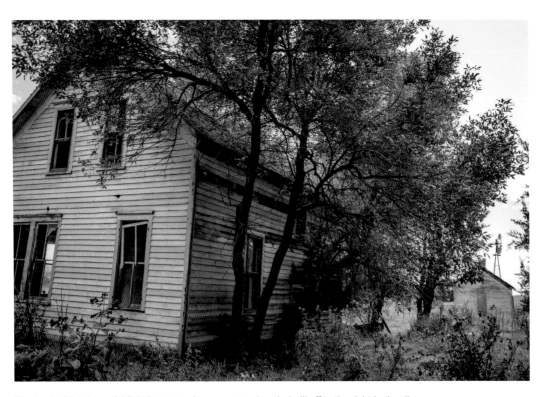

The back of this beautiful little house, and you can see the windmill off to the right in the distance.

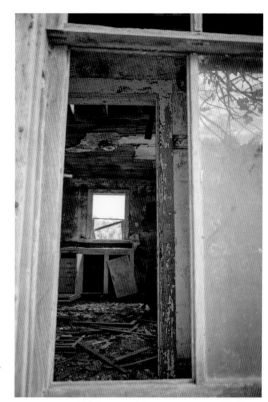

Right: The window looking into the kitchen.

Below: The front porch.

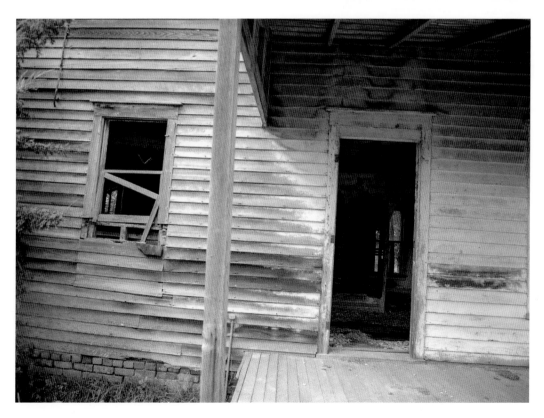

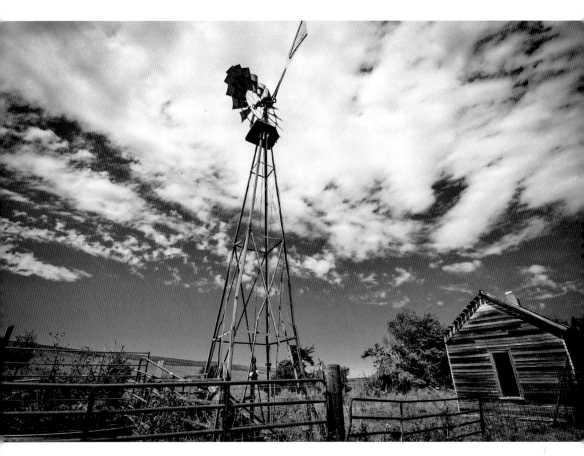

The windmill that still works and one of the other little outbuildings.

CEDAR VALLEY SCHOOL TURNED FARM

The next house was originally an old schoolhouse. It was called Cedar Valley School, and it was in use from 1888 to 1898. They had their centennial celebration the year they closed. Paul McIntyre was a principal during the school year, and then in the summer, he farmed and lived in this schoolhouse he converted into a little house for himself.

Paul had his pilot's license. Unfortunately, it did not end well for him. One night he became disoriented during a flight and lost sight of which way was up or down. He crashed the plane and died. I was able to speak to a couple of people who knew Paul, and they both told me what an amazing person he was.

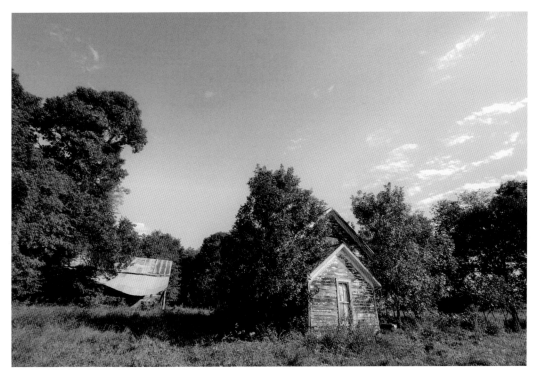

A black and white of the old schoolhouse turned farmhouse, and the barn.

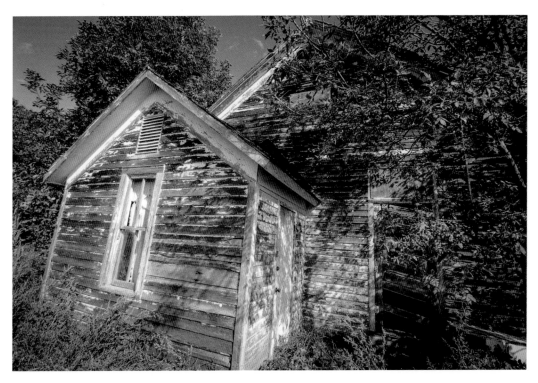

The front of the old schoolhouse turned farmhouse.

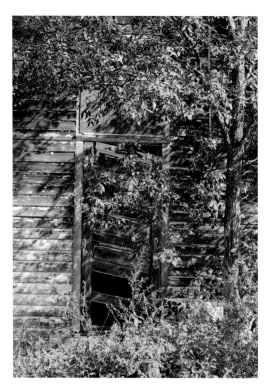

The broken front door of the school/house.

A close-up of the front doorknob.

A black and white of a discarded chair in the building in front of one of the chalkboards.

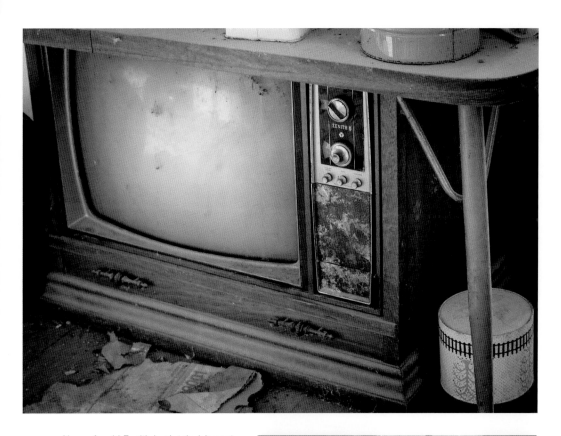

Above: An old Zenith knob television set collecting dust in the floor.

Right: I love this shot with the bike and the window.

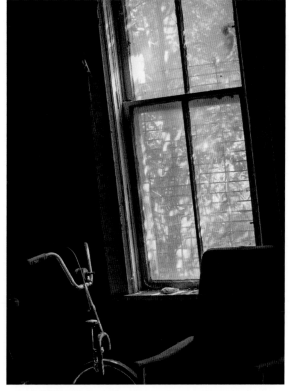

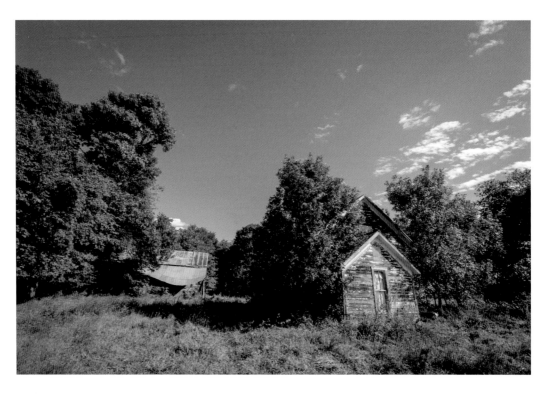

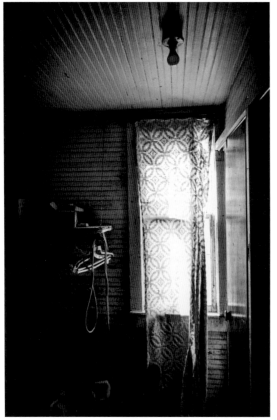

Above: The front of the school and the barn.

Left: A window in the front room of the converted school.

7

HOUSE MISSING ITS SIDE

Among the farms that I'm able to find the history on, there are those I am never able to find much information about. The next couple of houses were very difficult for me to find their history.

I came across this house by accident one day when GPS re-routed me down a forgotten road in the middle of farmland Nebraska. I turned my giant camper van around to get back to it. The house was missing the walls in the front, and the barn was still intact. There was an old truck off to the side of the farm, nestled in between a grove of trees and the crops.

I began shooting photos as fast as my hands would allow when a giant tractor pulling a huge trailer pulled in front of the house. The farmer who owned the property rolled down his window to find out what I was doing there. I explained who I was and what I wanted, as my dog snarled and barked from the passenger's seat of my van like she wanted to tear him apart.

He was very nice, explaining he did not mind if I continued taking photos, as long as I moved my van so he could pull in. I assured him I would not attempt to go too close to the unstable structure, as part of the home was sinking, in addition to the exposed side. He said no one had set foot in the home in over twenty years, but aside from that he did not know much more. I figured later I would be able to look the house up on my map and research the history. I was unable to find it again on the map.

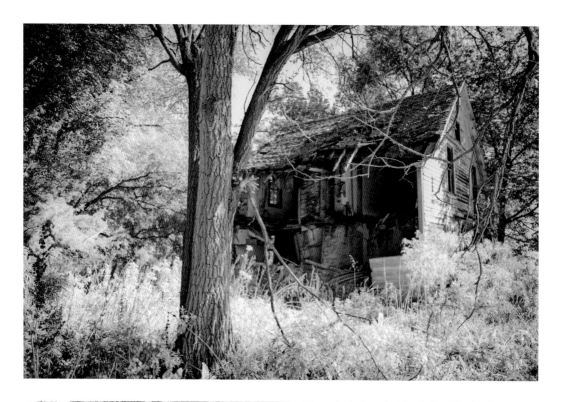

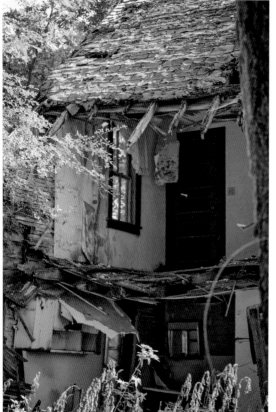

Above: A black-and-white photo of the front of this old farmhouse, missing its walls.

Left: A close-up of one of the doors of the interior of the home.

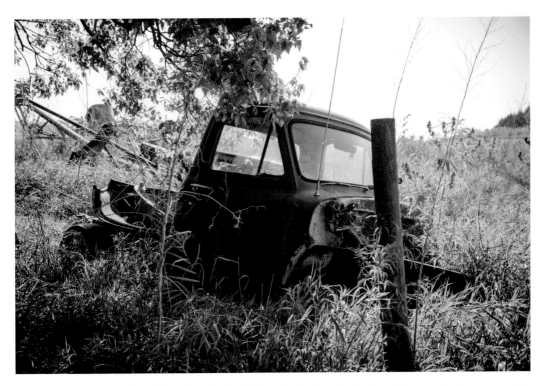

A photo in color of an old truck lost in the field next to the trees by this farm. I imagine the farmer who once drove it, driving to town.

A black and white of the house in the distance from the trees.

8

HOFFMAN HOUSE BETWEEN PAWNEE CITY AND STEINAUER

The community close to this little farm was settled in 1856 by three brothers who immigrated from Switzerland. It was named Steinauer, pronounced *Steener*, for Anton, Nicholas, and Joseph Steinauer. In 1854, several pioneers came from Ohio to the Nebraska area, traveling up the Nemaha River. On Turkey Creek, they came upon a Pawnee camp, and formed a settlement that became a trading post nearby. In 1855, it was selected as the county seat, being the center of Pawnee County. The post office was established in 1858, and the town Pawnee City was incorporated. In 1881, the railroad finished construction within Pawnee City. A massive fire struck on August 9, 1881, around 12:30 A.M., starting at the back of Reeder's Drug Store, rapidly spreading to twenty-six buildings. Using fireproof materials, the town rebuilt immediately.

According to the assessor's site, the house was built in 1900, the barn in 1967, and the garage and wooden crib in 1970. The house itself is caving in, so I had to be especially careful having my dog with me. This particular farm had been recently mowed, and cattle still grazed on the property. Someone obviously still farms the area, which is common with many abandoned farms. Most are not completely abandoned just because the home is unoccupied.

John Leonhardt (Leonard) Hoffman, was born in the 1830s in Germany. He immigrated to the U.S. in 1860, first to Wisconsin, and later to Nebraska. He also briefly lived in Canada. He worked in a copper mill, married Marguerite Gottula, and permanently settled down in Nebraska. They had several children: Julianna, John, Fredericka Louisa, Fredericka Kunagunda, Johanna, Katherina, John, Kathalena, Paul, Christine, and Louis. Margarette died in 1901. John passed away in 1905, just five years after the farmhouse was built.

Louis John Hoffman was born December 28, 1876. He married Rose Verena Sommerhalder on January 28, 1904, and they started a family of their own: Margaret,

Willard, Bernard, Vernon, Harold, Marvin, Rose, Louis, and Luella. Louis lived until 1950, and Rose until 1978.

According to what I could find, their son, Willard, next lived on the farm. He was born on the family farm, and grew up raising cattle. Willard married Phyllis Snyder, and they had children: Rodney, Doris, Byford, Max, and Marcia. He farmed and raised Jersey cows his whole life. He was one of the first in the county to upgrade his stock by using artificial insemination.

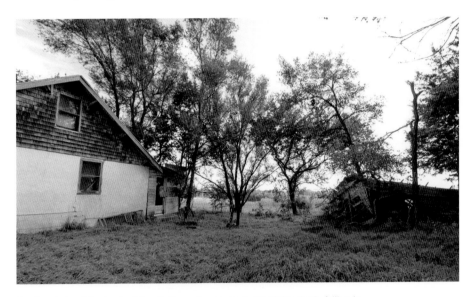

A color photo of the back of the Hoffman house, and one of the sheds falling in.

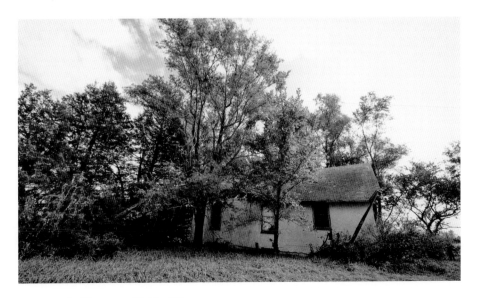

A black-and-white photo of the house.

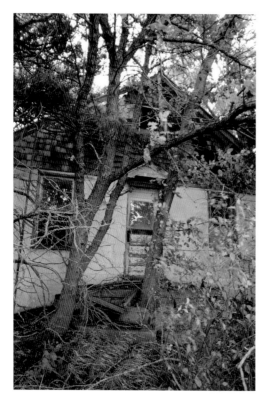

Left: The front of the house.

Below: One of the barns at the Hoffman farm, and a few sweet cows who were talking to me.

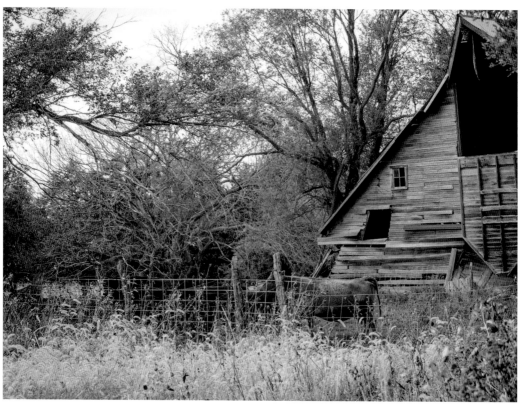

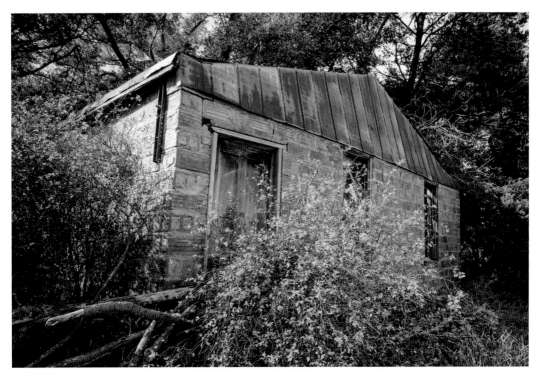

The brick building was so pretty for a garage or outbuilding.

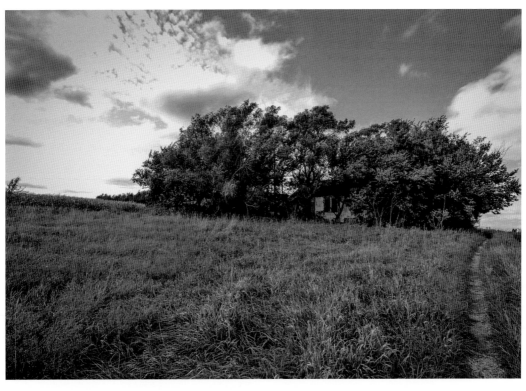

A black and white of the farm from down the drive on the other side.

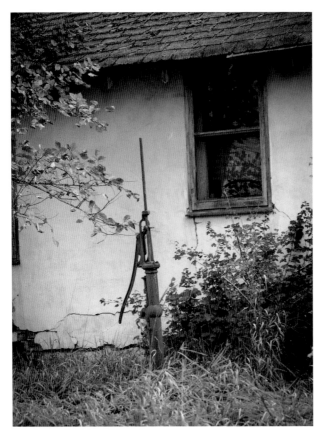

Left: Water pump on the side of the house.

Below: The side of the house.

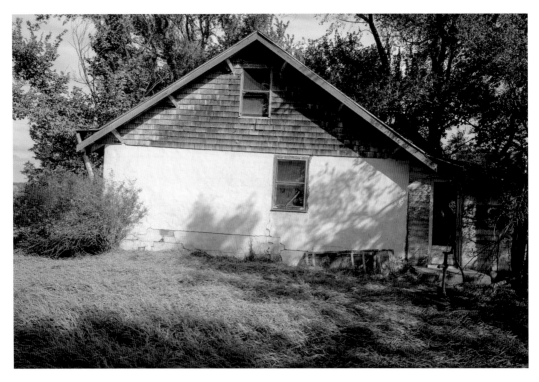

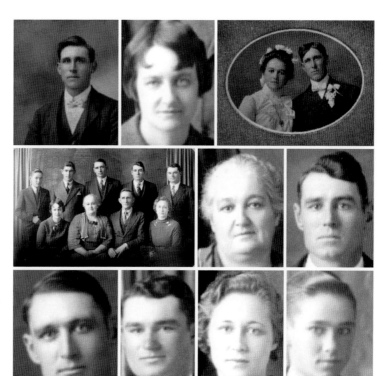

The Hoffman family, from the top left: Louis Hoffman, Margaret Hoffman, Rose and Louis (wedding photo); Middle Row: family photo: Willard, Bernard, Vernon, Harold, Marvin, Margaret, Rose, Louis, and Luella. The remainder are close-ups from the family photo.

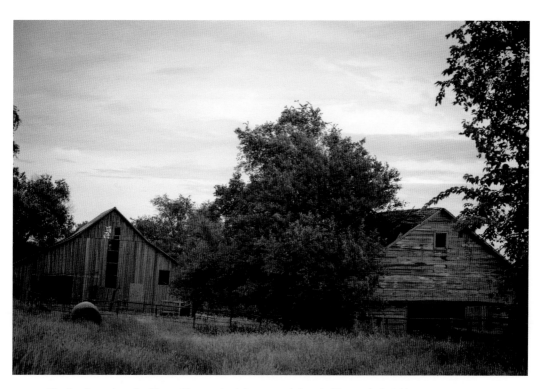

The two barns in color. The cattle were back here, very interested in my photo-taking.

9

THE RISING HOUSE OUTSIDE OF CRAWFORD

The next three houses are in my favorite area of Nebraska: Western Nebraska. The Sandhills are beautiful. Heading further west toward Crawford and Fort Robinson, the winding roads, craggy hills, and pine trees resemble Colorado or New Mexico.

This farm is such a beauty. I noticed it during my very first solo road trip through Western Nebraska and the Badlands. The house is not far from Crawford, which has so much history itself. Fur traders and trappers came to Dawes County in part of westward movement, along with ranchers with herds of longhorn cattle, and the United States Army. In 1885, the first railroad towns were built, with schools, churches, and many farms like this one. Crawford started as a tent city on landowner William E. Annin's property in 1886, when the Elkhorn, Fremont, and Missouri Valley Railroad pressed through the Nebraska panhandle. The soil in this area is saturated with history. Army Scout Baptiste (also known as Little Bat) Garnier was shot down in a saloon. Fort Robinson State Park is also close, which contains a monument to Crazy Horse (it was where he was held captive and killed). Calamity Jane, Doc (David) Middleton, poet John Wallace Crawford, and military surgeon Walter Reed, who vanquished yellow fever, were all in the area.

The home has a striking green roof and an inviting front porch, including an old chair that at one point was no doubt someone's favorite spot. When the sun sets, the final fingers of the day's light scrape across that large porch. The decaying barns peer over tall grass and fields full of crops. A windmill squeaks in protest with every gust of wind.

I uncovered that this house once belonged to the Rising family. Donald Keal Rising, or Keal as everyone called him, was born on July 27, 1929, to Ercil Jennie (Johnson) and Earl Rising. His parents were both from Iowa; however, Keal grew

up in Glen, Nebraska. He was one of six children. His siblings were: Doris, Wilbur, Marvin, John, and Eve.

Enlisting in the United States Army in 1948, he was assigned to the First Cavalry, Third Division, A Company, and was on a conveyance ship headed for combat in Korea on his twenty-first birthday. Just over a week later, he was fighting on the front lines with his squad. Keal had achieved the title of Staff Sergeant. He was honorably discharged in 1952, as one of only eight soldiers of the 142 men who touched down in Puchon that survived the war. He was often quoted, "Men who fought and died there knew darn well it was a war," and he grew upset when the press described Korea as a police action.

Keal met and married Velma Vallahan Rising on January 2, 1954. They became the parents to five children: Dixie, Donna, Rhonda, Kasey, and Roxanne. From what I uncovered, little Kasey Keal Rising was born January 1, 1959, and passed away in August of 1960. Roxanne Rising was born October 1959, and passed away in November of the same year.

Keal loved riding, and I found in his obituary that he never wanted anything more than to ride a good horse over a good piece of land. He was a ranch hand for multiple ranches in western Nebraska before buying a ranch of his own. Keal resided in his home until his death on February 26, 2003, when he died in his home. He participated in the Crawford Rodeo, competing in team roping and steer wrestling. He held the 3.5-second steer wrestling record at the Crawford Rodeo for almost twenty years, and assisted many young men in learning to wrestle steers, including his grandsons and nephews. He also qualified for the National Old Timers Rodeo in team roping. No matter how busy he was, he made time to saddle a horse and lead a child around the corral for their first experience. Keal was a pickup rider for thirty years, which is a person who rides on horseback in a rodeo in the rough stock competitions of bareback riding, saddle bronc riding, and bull riding. They play a vital role assisting rodeo riders and decreasing the danger of the competitors by assisting them at the end of his or her ride by riding next to the bucking horse and allowing the competitor to safely dismount from the animal, usually by grabbing the competitor or by creating stability while they jump free. Pickup riders usually work in teams of two. Normally, for bull riding in particular, they use rodeo clowns to shield the competitor from the bull.

I read that Keal's grandson said he was never afraid to ride a horse, because his grandad taught him how. Everyone who knew him said he was one of the last real cowboys, and he was proud of that. All he ever wanted was a good horse, and a good piece of land to ride it on, so every time I see this house, I picture a man on his horse off in the distance, with little kids trailing behind like ducklings.

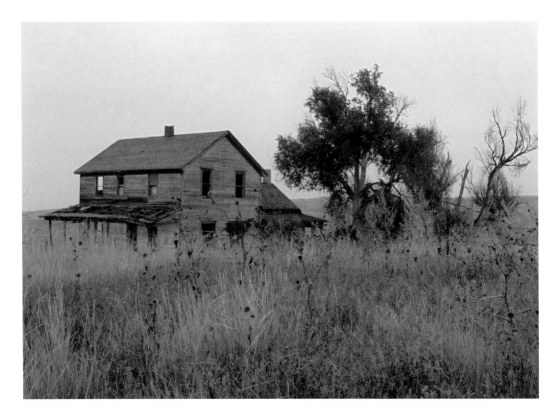

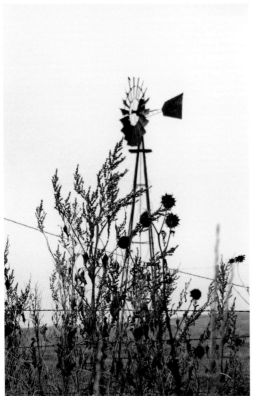

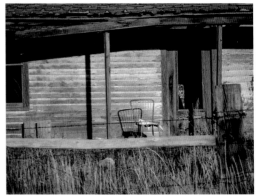

Top: Photo in color of the house through the grass.

Above: The front porch lit up by the setting sun.

Left: A black and white of the windmill.

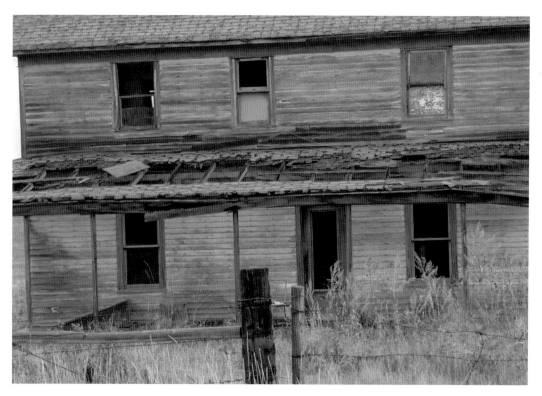

The front of the house.

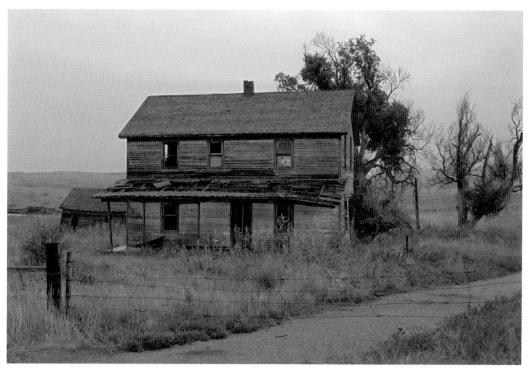

The green roof house front view.

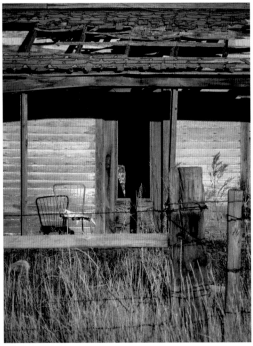

Some of the windows in black and white.

The porch.

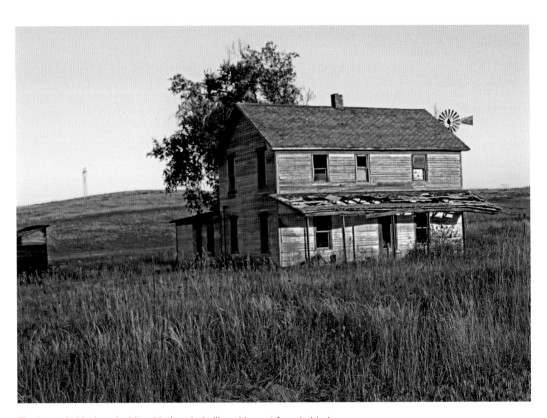

The house in black and white with the windmill peeking out from behind.

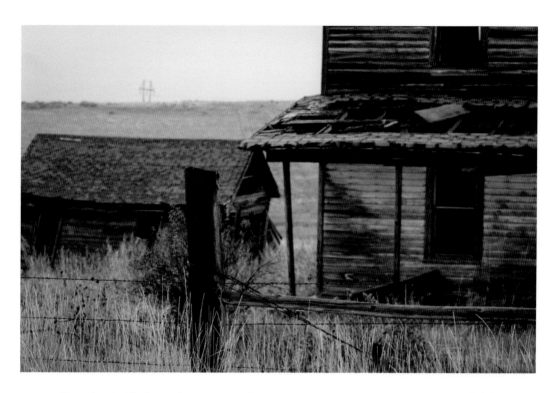

Above: A part of the fence, the porch, and the shed.

Right: A black-and-white photo of the farmhouse peeking over the tall prairie grass.

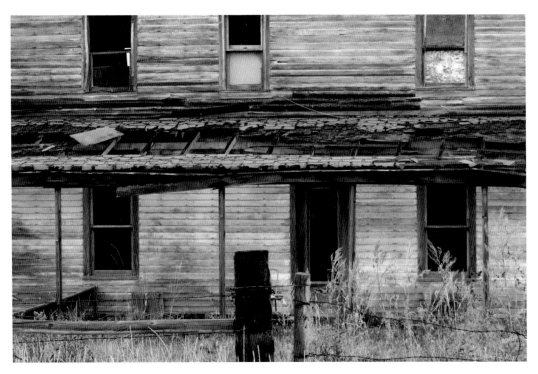

A black and white photo close-up of the front of the house.

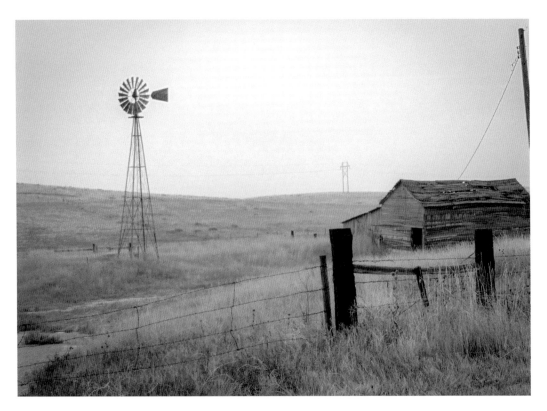

The windmill and shed.

10

ORELLA

Orella was formerly a small town in Sioux County, Nebraska, just outside of Toadstool Geologic Park. It was along the BNSF Railway Butte Subdivision, settled by immigrants in the 1880s when the Rosenberg and Wasserburger families established homesteads around Cottonwood Creek. They initially called the community Adelia. The railroad peaked Crawford Hill in 1889. They served as railheads for local ranchers to ship cattle. Due to steepness of the stop in Adelia, in the Spring of 1906, the railroad moved the telegraph office and water station from Adelia to the north. It was last inhabited in the 1960s, leaving the empty shells of homes—a missing piece to a puzzle. Adelia was renamed Joder, then the new railroad office location was renamed Orella after a local woman in town. Orella means divine message. Orella became home to the railroad track gang until 1960, when it was moved to Crawford. Cattle grazed throughout the land. They raise their heads as if to say, "What are you doing here?" What remains of Orella is very close to Toadstool Geological Park. If you have not been to this breathtakingly beautiful area of Nebraska, it is worth the drive.

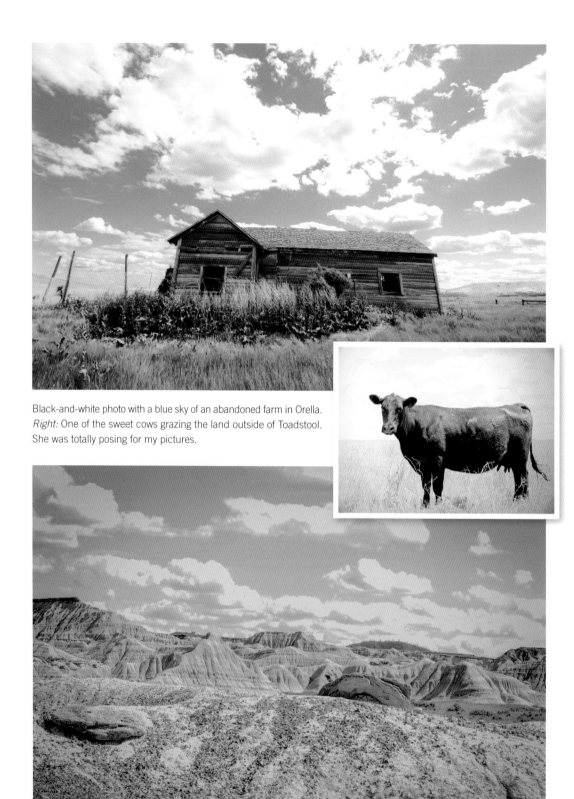

Black-and-white photo with a blue sky of an abandoned farm in Orella.
Right: One of the sweet cows grazing the land outside of Toadstool.
She was totally posing for my pictures.

Part of Toadstool Geological Park in Western Nebraska.

HOUSE NUMBER ONE IN ORELLA

One of the farms is still intact. According to the assessor's site, the house was built in 1900, the tool shed (detached garage) in 1920, and the loafing shed in 1930. I contacted the owner, and he chuckled when I called the buildings a house. A house? It's more like a shack out there. I don't know why you'd be interested in that. I explained why I was calling him, and he told me he had no idea who once lived there, but he thought at one time it was a restaurant of some kind. I told him on the assessor's site it was labeled as a farm. He erupted in laughter again. "I don't know about that. No one has lived out there in years. There was a train car, and across the road where the train tracks were, the guy that worked on the trains used to live in one of those houses, but I have no idea who owns it now."

When I explored this property, I found no evidence that it was ever a restaurant, and I did not see a train, but looking at the photographs, I can see why he would say there is a passenger train car on the property. The long part connected to the house resembles an old passenger train car.

The property also contained a plow, and other buildings commonly associated with a farm. There could have been a restaurant on the property with a train car, and later it was converted to a farmhouse.

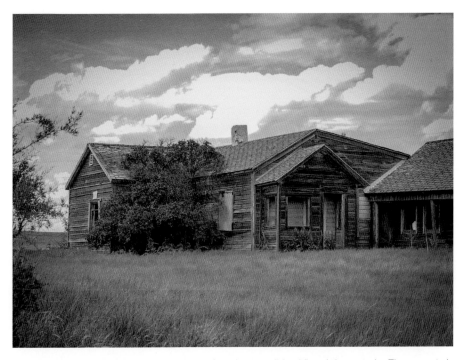

A photo of the farm that the current owner referred to as a "shack" and then a train. The property is labeled a farm on the assessor's website.

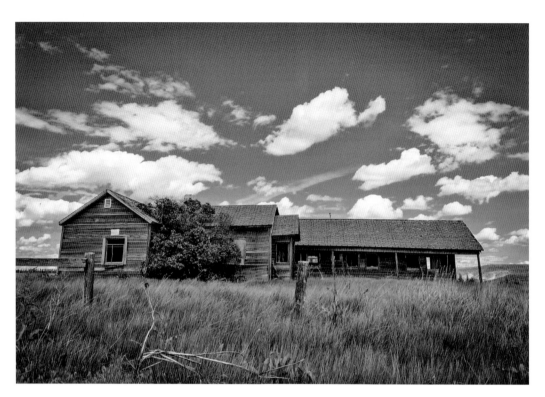

Another view of the farm from the front in black and white.

The plow on the property next to the fence.

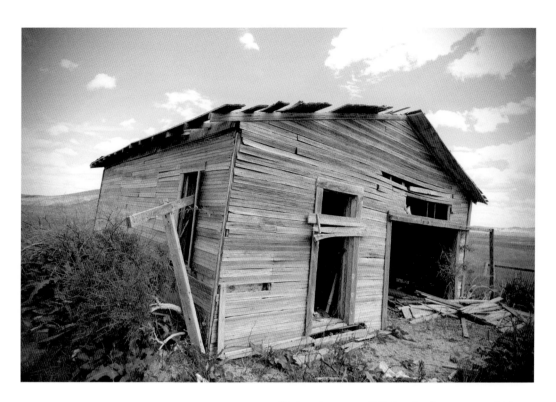

Above: One of the outbuildings on the farm.

Right: The recliner through one of the fractured windows.

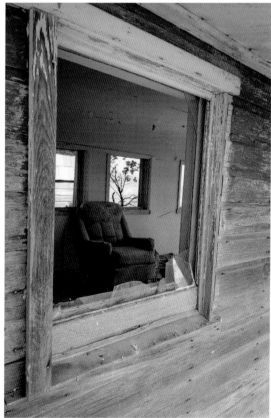

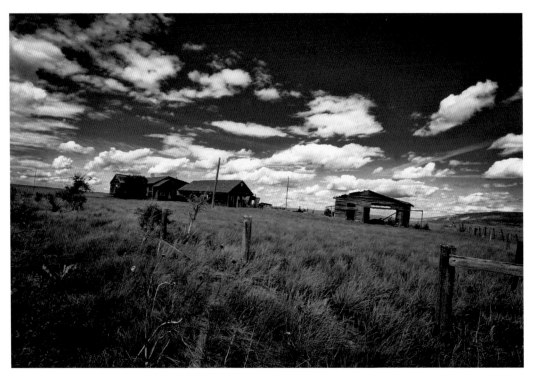

A black-and-white photo of the house and the detached garage or loafing shed.

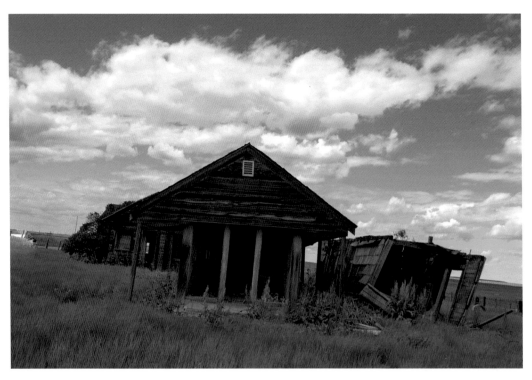

The open end revealing the recliner, and the wooden storage shed behind the house that also could have been a train at one point.

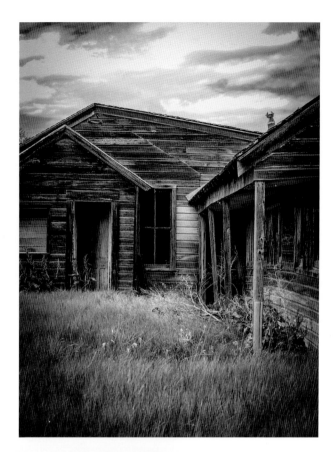

Right: A black and white of the front door.

Below: Another shot of the recliner.

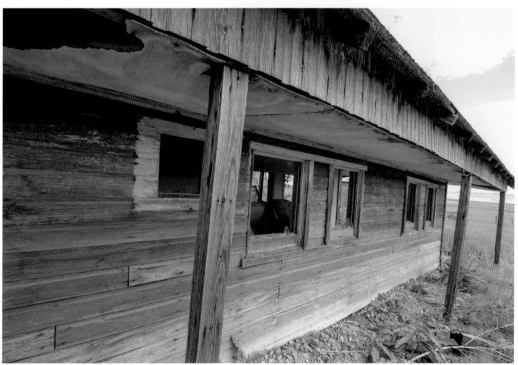

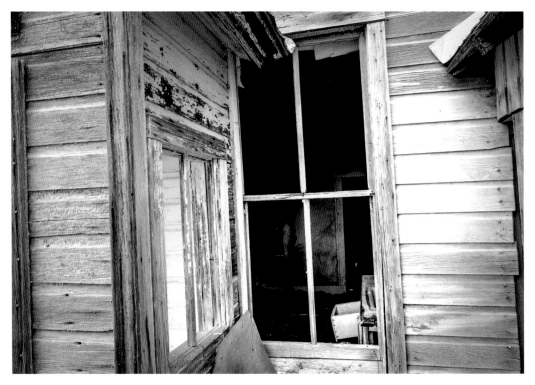

Peering in through one of the windows, capturing the sink.

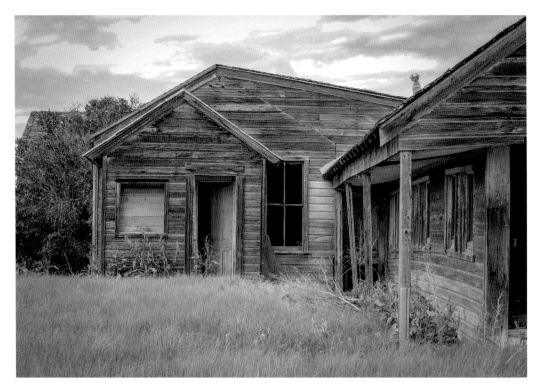

Another shot of the house.

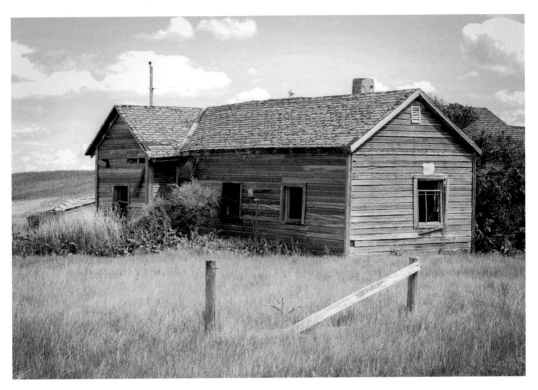

The other side of the house, visible from the road.

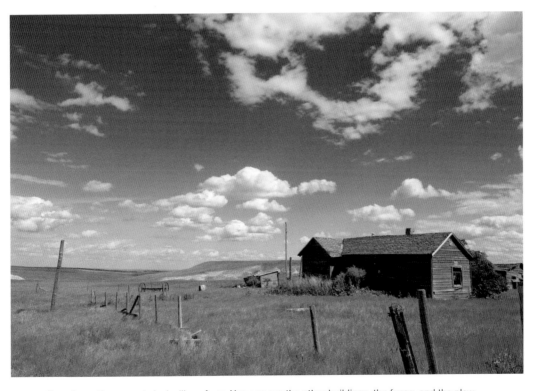

From here, the property looks like a farm. You can see the other buildings, the fence, and the plow.

ORELLA HOUSE NUMBER TWO AND THREE

As I mentioned previously, there are other houses across the road behind the railroad tracks.

I was unable to find out exactly who lived on these properties. I found a few primary families who lived in the area. Some farms had been torn down. The only evidence of them were piles of boards and rubble.

As previously mentioned, the two families who started the town were the Wasserburgers and the Rosenbergs. Joseph Charles Wasserburger was born February 28, 1884, one of eleven children. His father, Henry Waserburger was from Germany. Joseph served in the military in 1917 and 1918. He married Elizabeth (Bessie) Gargen Wasserburger (born Carnhan). Together, they had five children: Eugene (Gene), Joseph, Esther, Cecil, and Lawrence (Bub). Gene married Thea Davis in 1939, and even though they never had children, he dedicated his life to serving his community. They were happily married for fifty-nine years. Gene was employed at Fort Robinson in the Post Engineer's office. In 1943, he was drafted into the Army, working in the Corps of Engineers, participating in the invasion at Normandy at Omaha Beach. He was discharged in 1946, with the rank of Sergeant. He worked at a grain company until his retirement. In 1983, Gene was honored in the *Scottsbluff Star Herald* as "A Good Neighbor" for his years of service to the community. He delivered meals to patients in the Crawford Hospital and coffee to Ponderosa Villa. He assisted at the visitor center, provided respite care, and volunteered on the Crawford fire and rescue department for twenty-six years.

Nelson T. Rosenberg immigrated from Sweden to Sugarloaf in 1900. When it was still up and running, he ran the store.

I also found that the final family residing in Orella was the Carnahan family. John G. Carnahan was born to Margaret (Kibler) Carnahan and James R. Carnahan on March 30, 1892, at Mendota, Missouri. His only sister, Bessie Wasserburger, had passed away, and he had one brother, Jerry. His father worked in coal mines. Mable (Miller) Carnahan was one of ten children. John and Mable were married in 1915; first moving to Hermosa, South Dakota, and finally to Orella, Nebraska. John and Mable had six children of their own, five boys and one girl. They lived in a small railroad section house. There were tough times, including dinners of corn meal mush. John almost died twice, once from sepsis (blood poisoning), and the other by a rattlesnake bite to the finger by a hidden snake. A spark from a train once landed on a stack of laundry Mable was folding next to the tracks, and burned the entire pile. John and Mable both retired at the same time; John after fifty years from the railroad as a section foreman, and Mable after twenty years as the postal worker in

Orella. They enjoyed celebrating their 60th wedding anniversary with their family before John passed away later that year. All the Carnahan children spoke fondly of their childhood in Orella, roaming Toadstool, scaling Sugarloaf Butte. Jack was born in 1920, and passed away in August of 2019. He was the third child of seven. John left most of the work on the ranch to the boys while he worked on the railroad. In 1932, they owned a flock of sheep, and one summer Jack was the responsible herder below Sugar Loaf. At the time, coyotes were rampant throughout the area, and if they left the flock unattended even if for a moment, they would lose several lambs. They lost over 100 lambs before the government gave them poison for the coyotes, so they stopped raising sheep. They obtained more land in the 1930s, mostly badlands, and in 1942 they purchased 480 acres near Whitney. In 1944, Jack joined the Navy, and served in World War II on Naval Destroyer USS *Storm*, and his ship was bombed by a Kamikaze. He recalled that the Japanese bombed their ship every night. Jack turned twenty-five on the very day the U.S. dropped the atomic bomb on Hiroshima. He was discharged to return home, and purchased the ranch. Jack married Peggy Mittan, and they had a family of their own, having five children on the ranch in Whitney.

Ansel Carnahan graduated from high school at the young age of sixteen, spending the next few years exploring the west from his Harley Davidson, and making a living by sheering sheep on local ranches. Ansel also served in World War II as a Lieutenant in the Medical Corps, meeting his wife, Ann Scutakes (they were married six weeks after they met), and celebrating sixty-one years of being married. He became a veterinarian in 1952. Ann and Ansel had three daughters of their own, and together they ran a veterinary practice for over fifty years. He loved singing cowboy songs and telling stories. Bob Carnahan was born August 6, 1922, and just like Jack, he moved to Whitney, caring for his own wheat crops and livestock. Bob moved to Fort Collins, Colorado, in 1948, attending CSU (A&M at the time), and then returned home after a blizzard in 1948/49 to help his family tend to the ranch during the aftermath. He returned to college in the fall closer to home in 1949, and met Annabelle. He and his wife, Ann, were married on August 16, 1953. Bob went on to complete medical school. Everyone referred to him as "Dr. Bob," and he proudly treated thousands of patients in his orthopedic practice before retiring in 1987 in Wyoming. He and Ann also purchased a cattle ranch in western Nebraska close to the Carnahan homestead. Bob and Annabelle had two sons. All I could find on Richard Carnahan was he was born June 7, 1926, and passed away July 1983, at fifty-seven years old. I could not find much about Kenneth or Dorothy.

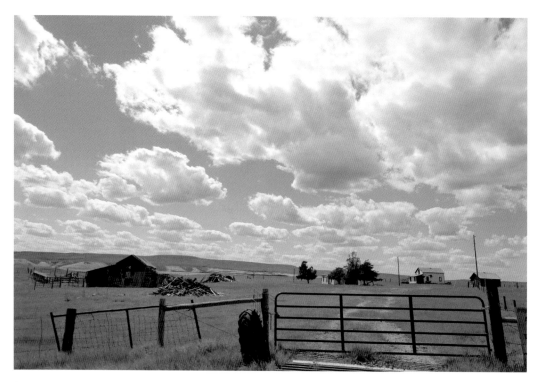

A color photo of the houses and barns behind the railroad tracks.

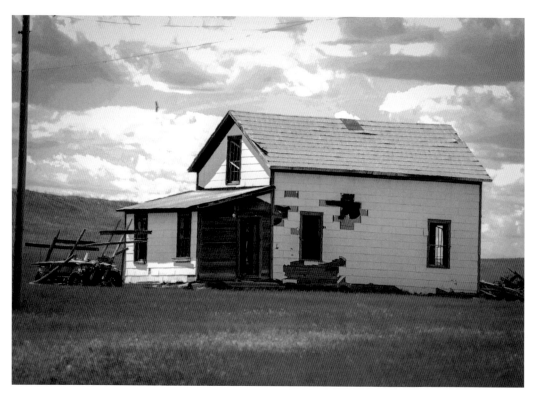

A black-and-white photo of the large white house.

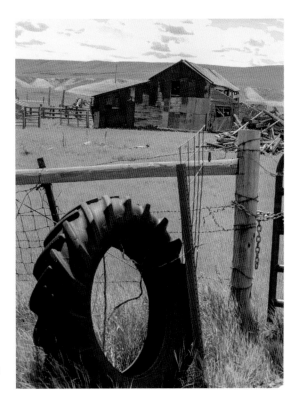

Right: The large barn, rusting against the blue sky.

Below: One of the other houses, now a mere shell of what it once was.

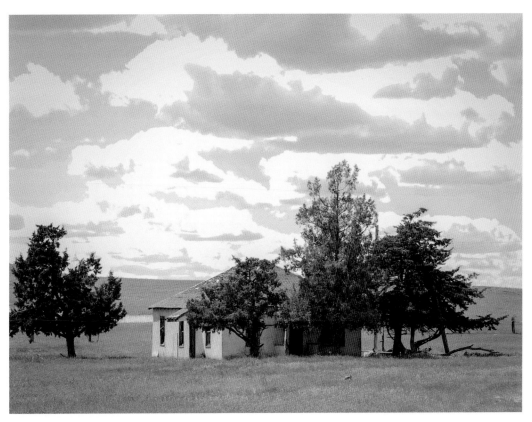

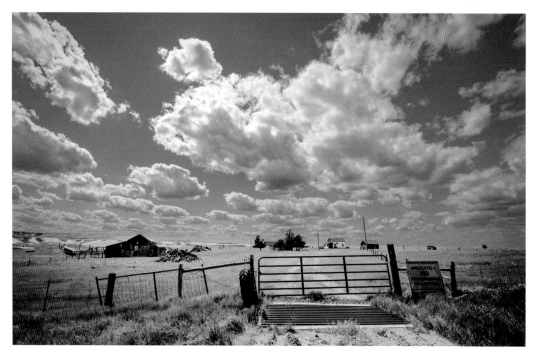

A black and white photo, with the sky in color. This shows the large no trespassing sign, a reminder that this is still private property even though it appears to be abandoned.

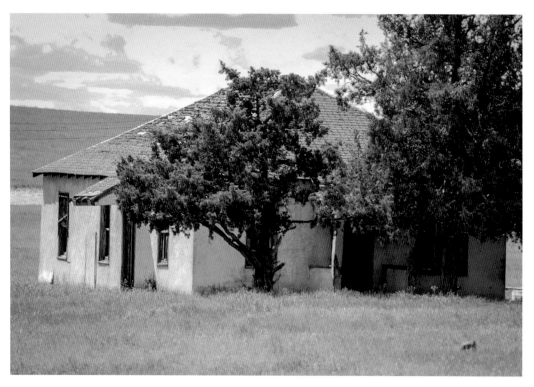

A close-up of the smaller house. I used my telephoto lenses on this property, as I was uncomfortable passing the fence.

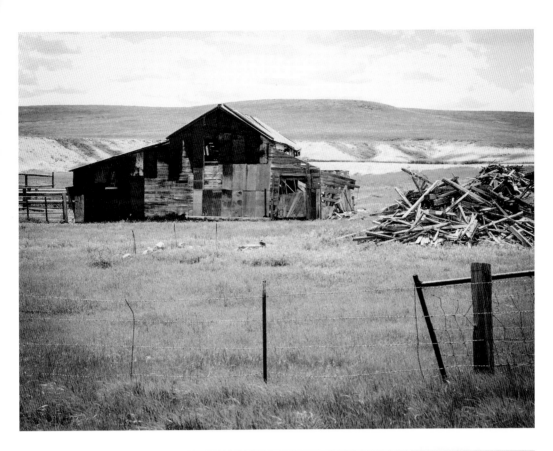

Above: A black and white close-up photo of the larger barn.

Right: Photos of Jack Carnahan at age twenty-five to the left during World War II (in 1944), and on his ninety-fifth birthday on the right. [*Photos courtesy of the Chadron Record*]

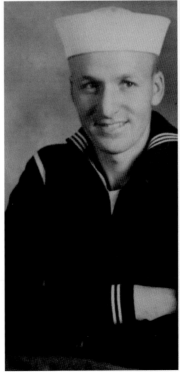

11

HOUSE NEAR OSAGE

This house was around the Osage area. The farm still had a barn, a corn crib, an outhouse, and another building with an entire side exposed. I noticed two stone pillars that were possibly the base of a sign or lights. There were also stone steps that led to nothing, leading me to believe there was a house at the top of the steps. I think the other building must have been some kind of shed, although it did have a basement. It was a strange property.

The current owner acquired the property last spring, and farms the land around the buildings. He was uncertain about the farm's past. Upon further research, I found the family's estate name, Dettmer. The farm belonged to Donna Belle Elizabeth Dettmer and her husband. Donna was born August 1, 1929, to parents Fred Carl Naber, and Pearl Marie Holscher Naber. She moved to a farm in rural Nebraska at the age of one-and-a-half years old. Donna completed a secretarial course, graduating from the Lincoln School of Commerce.

Donna married Arthur Dettmer on March 4, 1952. Art was born to William Dettmer and Hattie Kirchhoff Dettmer. After Art was discharged from the Airforce, they had four children together: Annette, David, John, and Allen. Donna was a nursing assistant for seventeen years, and a volunteer for the VFW Auxiliary. Arthur preceded her in death in 2006. She passed away at home, surrounded by family. This farm is such a peaceful property, nestled in the cornfields. As I watched the angry clouds swirl closer to the ground, I found myself lost in the hissing wind.

All these farms are shells of what they once were, like fossils of the all-American family. Places that were homesteaded by ancestors who suffered and sacrificed to ensure their family was able to partake of the family dream. The next time you pass a barn, with its weathered slats filtering the setting sunlight, picture Arnold Warner and his sweet wife Rose. Think of the Burgers, and the generations who laughed, lived, and poured their

sweat into the land. Think of the Rising family, and one of the last cowboys showing his grandchildren how to ride horses. Remember the families from Orella and Sugarloaf, who skipped warm meals at home in order to protect their sheep from coyotes. Think of those who grew up to serve their country and communities. These places are so much more than the abandoned structures you see now. They are our history.

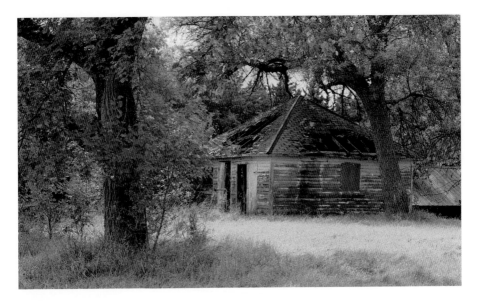

A photo of the outbuilding or house.

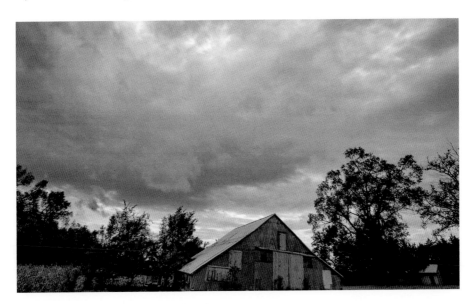

The barn with storm clouds brewing above it.

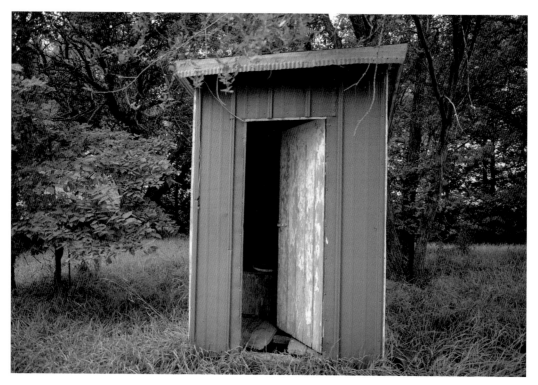

A picture of the outhouse behind the main building.

A black and white of the barn in the background with the rock bottom of one of the pillars.

Right: An old ice box with the door completely broken off leans forward in the exposed building.

Below: The building missing its side.

Above: The front of the building through the trees.

Left: An old bottle rests against the wall, discolored from the years.

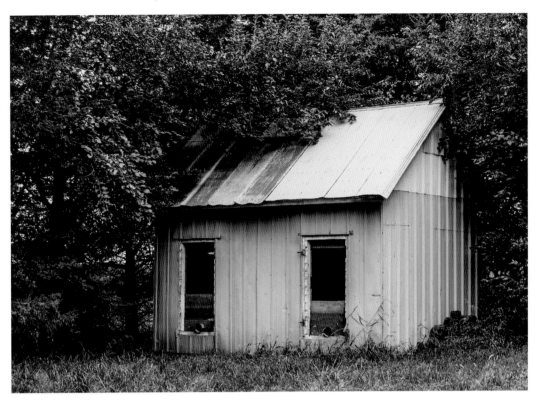

One of the other buildings in black and white.

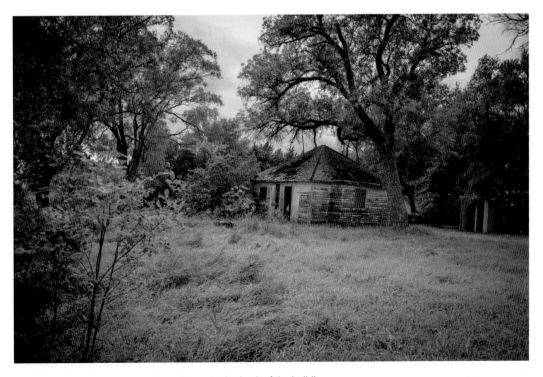

I love how you can see the outhouse to the back of the building.

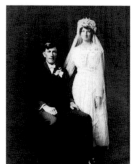

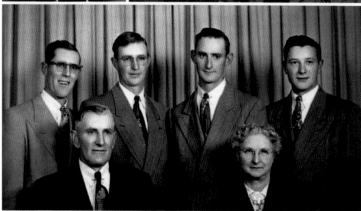

The Dettmer family. Starting from the top left corner: William and Hattie (Art's parents); Top right corner: Art and Donna; Bottom, starting from the back row: Elmer, Harvey, Vernon, Art, with William and Hattie on the bottom.

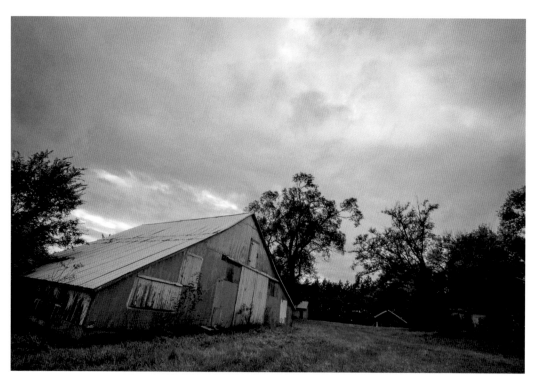

The barn, with the other buildings showing off to the right side.

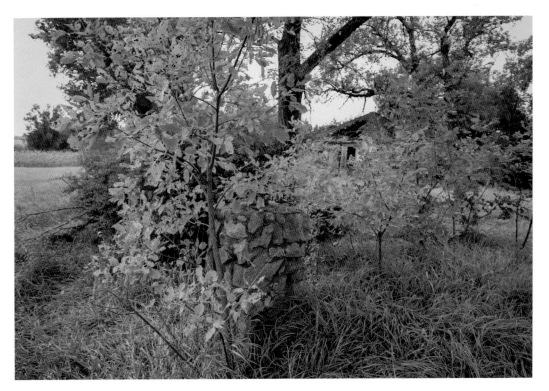

The house peeking through the leaves.

One last look at the barn.

RESOURCES

The Bonwell/Warners: Photos of the Bonwells/Warners from My Heritage. Newspaper references from *The Syracuse Journal-Democrat*, and *The Nebraska City News-Press*.

The photos of the Burger family courtesy of the family.

The Dettmer photos: the photo of Donna and Art is from Find a Grave; the photo of his family and parents from Ancient Faces.

The Hoffman family photos are from My Heritage.

The Carnahans: The family history and photos came from Jack Carnahan's obituary, and *The Chadron Record*.

The Rising family: the history of the family is from obituaries and Find a Grave.

The Parkhurst Farm (Mark Morton's summer home): Photo of the family and the house per the Sterling Morton Library, with permission; the photo collage of the house in the 1970s provided by History Nebraska. The family history from Find a Grave, History Nebraska, the Morton Arboretum, *The Lincoln Star*. On Helen Bayly (Morton): *The Los Angeles Harald*, Volume XL, Number 211, July 6, 1914.

The Horse Creek Murder references: *The Grand Island Independent*.

The photo of Camp of the Pawnee on the Platte Valley per the Library of Congress.

The Kahnk house: My Heritage, Find a Grave, and *The History of Dodge and Washington Counties, Nebraska, And Their People Volume 2* by William Henry Buss.

The Luft house: obituary and Find a Grave.